BEYOND GREEN

toward a sustainable art

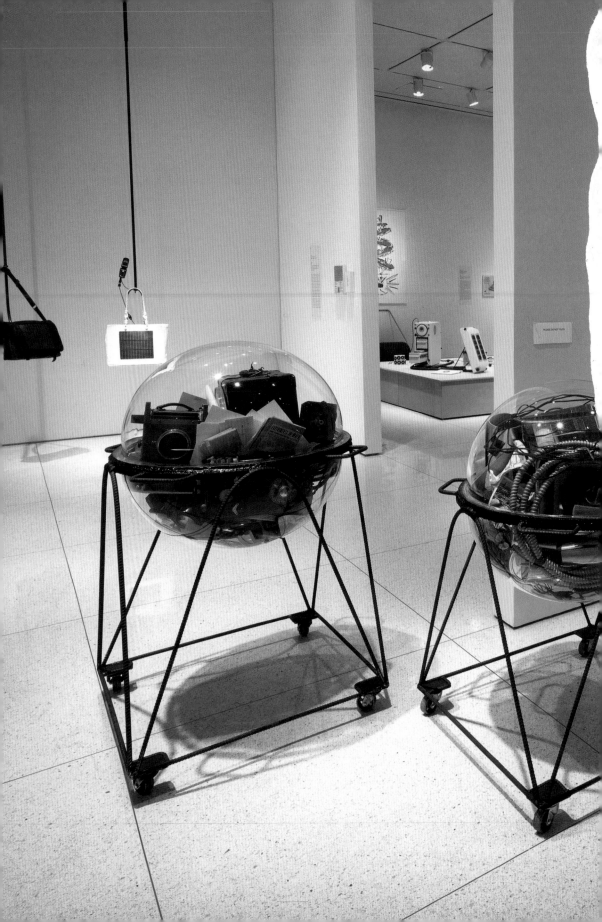

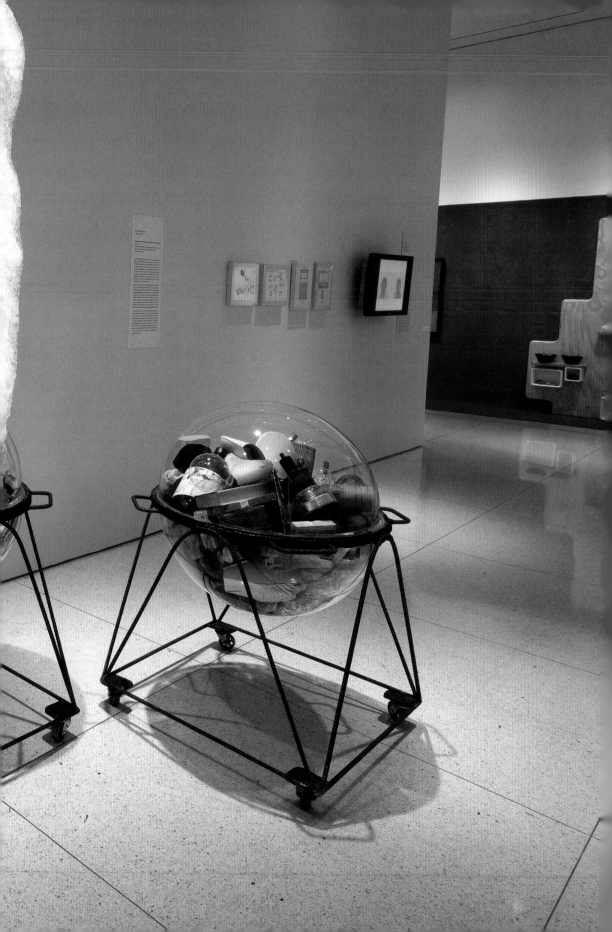

Allora & Calzadilla

Free Soil

JAM

Learning Group

Brennan McGaffey in collaboration with
 Temporary Services

Nils Norman

People Powered

Dan Peterman

Marjetica Potrč

Michael Rakowitz

Frances Whitehead

WochenKlausur

Andrea Zittel

BEYOND GREEN

toward a sustainable art

Curated by Stephanie Smith

SMART MUSEUM OF ART
UNIVERSITY OF CHICAGO

INDEPENDENT CURATORS INTERNATIONAL
NEW YORK

Published to accompany the traveling exhibition
Beyond Green: Toward a Sustainable Art,
co-organized by the Smart Museum of Art,
University of Chicago, and iCI (Independent
Curators International), New York, and circulated
by iCI.

The exhibition is curated by Stephanie Smith,
Smart Museum Curator of Contemporary Art.

This exhibition and accompanying catalogue
are made possible in part by the Smart Family
Foundation, the Horace W. Goldsmith
Foundation, the Richard H. Driehaus Foundation,
Nuveen Investments, Tom and Janis McCormick
and the Kanter Family Foundation, and
iCI Exhibition Partners Kenneth S. Kuchin
and F. Bruce Anderson, and Gerrit and Sydie
Lansing. Additional support is provided by
the Arts Planning Council, the Environmental
Studies Program, and the Green Campus
Initiative, University of Chicago.

ISBN: 0-935573-42-9

Library of Congress Cataloging-in-Publication
Data

Beyond green : toward a sustainable art /
curated by Stephanie Smith.-- 1st ed.
 p. cm.
Catalog of an exhibition at the Smart Museum
of Art, University of Chicago, Oct. 6, 2005-Jan.
15, 2006 and at three other locations.
ISBN-13: 978-0-935573-42-8 (alk. paper)
1. Art, Modern--21st century--Themes, motives--
Exhibitions. 2. Ecology in art--Exhibitions. 3.
Art--Social aspects--Exhibitions. I. Smith,
Stephanie, 1970 - II. David and Alfred Smart
Museum of Art. III. Independent Curators
International.
N6496.C52D383 2005
709'.0507477311--dc22

2005031862

Exhibition Itinerary:*

6 October 2005–15 January 2006
Smart Museum of Art, University of Chicago

2 February–7 May 2006
Museum of Arts & Design, New York

5 May – 15 July 2007
Contemporary Arts Center, Cincinnati

14 September–7 December 2007
Richard E. Peeler Art Center, DePauw University
Art Museum, Greencastle, Indiana

*at time of publication

Design: JNL Graphic Design, Chicago
Editor: Stephanie Smith
Copy Editor: Greg Nosan
Publication Assistant: Rachel Furnari
Printer: Oddi Printing, Iceland

Smart Museum of Art
University of Chicago
5550 South Greenwood Avenue
Chicago, IL 60637
773.702.0200
http://www.smartmuseum.uchicago.edu

Independent Curators International
799 Broadway, Suite 205
New York, NY 10003
212.254.8200
http://www.ici-exhibitions.org

5/11/07

$21.13

YBP

CONTENTS

Foreword
and
Acknowledgments

Organizing a traveling exhibition that addresses the intersection between sustainable design and contemporary art poses particular challenges: how to be thrifty and environmentally conscious in presenting, interpreting, packing, and shipping works of art. This problem would be germane only to those of us in the business of art exhibitions if it did not also speak to the ways in which we as a society and as individuals consume resources in an increasingly globalized sphere of interactions. These days, we order furniture produced on the other side of the world and have the pieces shipped to us from distant warehouses, eat produce grown on different continents, and buy clothes made from fabrics woven and tailored across the globe. It takes effort to go past superficial understandings of "green living" in order to live in a truly sustainable way.

The artists in *Beyond Green: Toward a Sustainable Art* bring these questions into the production and circulation of their own work. We thank them for creating a remarkable array of projects and for sharing them through this exhibition. These artists offer counterpoints to established forms of environmentally conscious art: rather than large-scale interventions, they explore sustainability at a more modest, portable level. Some adopt proven principles of "green" design. Others propose small-scale, alternative modes of living. Still others incisively highlight the problems and contradictions of the very discourse of sustainability. Absent from *Beyond Green* are more familiar forms such as community gardens, planning projects, or public art. Though all of the artists have, in fact, worked site-specifically, with particular communities, ephemerally, or outside the boundaries of art museums, the works presented in *Beyond Green* demonstrate a specific curatorial choice to feature another side of these practices: structures, objects, and processes that can be used and reused in a range of contexts and can be experienced directly by visitors at each exhibition tour venue. The curatorial approach to *Beyond Green* thus brings recycling—one strategy of sustainability—into the world of art.

Collaboration—another critical element of sustainable living—has permeated all levels of planning for *Beyond Green*. This complex exhibition has required intense levels of collaboration among curator, artists, and many others, and we thank Stephanie Smith for her curatorial vision and dedication as she knitted together not only the content of the show, catalogue, and accompanying programs, but also the networks of people and relationships that have shaped *Beyond Green*. Likewise, the partnership between the Smart and Independent Curators International has enabled us to leverage resources to make possible the exhibition, tour, and catalogue as well as related programs. In Chicago, where this project initially took shape, we benefited from the early involvment of several individuals, groups, and university departments. We are especially grateful to Dave Aftandilian of the University of Chicago's Environmental Studies Program, the Chicago Architecture Foundation and its curator Ned Cramer, Ken Dunn of the Resource Center, Peter Nicholson of Foresight Design Group, and Kevin Pierce of the architecture firm Farr Associates, for their ongoing feedback, ideas, enthusiasm, and support, which significantly extended the range and reach of the exhibition. We are also grateful to the University of Chicago's Green Campus Initiative, the Department of Visual Arts, the Environmental Studies Program, the Office of Community and Government Affairs, the University Community Service Center, and the Workshop on the Built Environment for pushing beyond traditional disciplinary boundaries to help us involve audiences in tackling real problems of art and sustainable design. Without them, most of the programs presented in conjunction with *Beyond Green* in Chicago would not have been possible. We extend special thanks to the artists who participated

in several ambitious university programs inspired by the exhibition: a summer 2005 course on art and activism that artist Kevin Kaempf of People Powered taught for high school students in the university's Collegiate Scholars Program; Nils Norman's fall 2005 residency teaching an interdisciplinary course on art and environmental activism; and WochenKlausur's intensive three-week residency during summer 2005 to create their exhibition project with the help of a team of university students (listed on page 142).

None of this would be possible without the support of visionary funders. We sincerely thank the Smart Family Foundation, the Horace W. Goldsmith Foundation, and the Richard H. Driehaus Foundation, as well as iCI Exhibition Partners Gerrit and Sydie Lansing, and Ken Kuchin and Bruce Anderson, for their generous support of this project. We also thank the Arts Planning Council at the University of Chicago for encouraging greater involvement by university students through their grant. The Smart also acknowledges the critical support of the Illinois Arts Council, a state agency; Nuveen Investments; and Tom and Janis McCormick and the Kanter Family Foundation for their support of Smart Museum exhibitions. We offer them our deep thanks.

We also thank Susan and Michael Hort for lending work to the exhibition. Additional thanks are due to Chantal Crousel Galerie, Klosterfelde Gallery, Lisson Gallery, Lombard Freid Projects, Galerie Christian Nagel, Max Protetch Gallery, and Andrea Rosen Gallery for their support of the artists' work and their ongoing assistance with *Beyond Green*. Josie Browne at Max Protetch and Susanna Greeves at Andrea Rosen deserve additional thanks for their assistance in facilitating loans.

We also thank those who made special contributions to this catalogue. Victor Margolin offered support and expertise during the book's conception and production. His essay allows us to consider the ideas put forth in the exhibition within the context of an expansive framework of social, ecological, and political involvements with sustainability. Jason Pickleman of JNL Design translated the concepts of the exhibition into graphics and catalogue, providing a visual identity to the project as it travels. From the beginning, he understood and embraced the challenges of designing a book that articulated sustainable design in both form and content. Greg Nosan provided excellent editorial guidance.

Many individuals on both our staffs have contributed their professional skills, creativity and enthusiasm to planning, fundraising, catalogue production, presentation, programming, and touring. At the Smart we offer special thanks to deputy director for collections, programs, and interpretation Jacqueline Terrassa, who shepherded the project during her term as interim director and worked closely with Stephanie Smith to develop the programs that accompany the exhibition's Chicago presentation; project interns Sara Black, Rachel Furnari, and Kristin Love Greer for their skill, dedication, and grace under pressure; deputy director for development and external affairs Shaleane Gee; public relations and marketing director Christine Carrino; manager of education programs Amanda Ruch; and the registration and preparations staff who so ably addressed the special requirements of this exhibition—Lindsay Artwick, Rudy Bernal, and David Ingenthron. At iCI, we thank director of exhibitions Susan Hapgood, former exhibitions associate Amy Owen, exhibitions assistant Ramona Piagentini, registrar Beverly Parsons, and intern Erica Hope Fisher for their management of this complex exhibition, catalogue, and tour; director of development Hedy Roma and development assistants Hilary Fry and Katie Holden for skillful fundraising efforts; and communications coordinator Sue Scott for her public relations work.

Finally, we extend our warmest appreciation to the trustees of the Smart Museum of Art and of Independent Curators International for their continuing support, enthusiasm, and commitment to our respective institutions. They join us in expressing our appreciation to everyone who recognized the importance of this project and gave generously in so many ways to ensure its success.

This exhibition is an especially appropriate collaboration for our two institutions, as it draws on a shared commitment to presenting significant developments in contemporary art in relation to current cultural trends and issues. It continues a series of exhibitions organized by Stephanie Smith for the Smart Museum of Art that explore critical art practice—conceptual and socially engaged work involving multiple constituencies, sites of production, and strategies for collaboration. Likewise, iCI's program of traveling exhibitions of contemporary art takes as one of its priorities a focus on critical issues in artistic and curatorial practice. *Beyond Green* builds on these histories by introducing us to exciting artistic developments and providing a new way of seeing art within a framework of sustainability. Even as they speculate in other disciplines, the works in *Beyond Green* can be best understood as artwork, not as design, architecture, or activism. They are for the most part provisional rather than practical, polemical and opportunistic rather than reasonable. Some can be used to effective ends, but ultimately they offer us a playful and yet entirely serious meditation on how we can use the resources at hand to sustain responsible living.

Anthony Hirschel
Dana Feitler Director
Smart Museum of Art
University of Chicago

Judith Olch Richards
Executive Director
Independent Curators International
New York

Beyond Green

by Stephanie Smith

Sustainable design has the potential to transform our everyday lives through an approach that balances environmental, social, economic, and aesthetic concerns. This emerging strategy emphasizes the responsible and equitable use of resources and links environmental and social justice. By doing so, it moves past a prior generation of more narrowly eco-centered or "green" approaches. Although still a fledgling movement, this holistic, ethical, pragmatic, and wildly inventive mode has the potential to redirect design toward progressive ends, a phenomenon that designer Bruce Mau succinctly dubbed "massive change."[1] This shift derives from and speaks to a much more widespread desire to find socially and environmentally responsible—in other words, sustainable—ways of living and working, a desire being enacted around the world in large and small ways not only by activists and designers but also by growing numbers of corporations, policy makers, and possibly even you.

Beyond Green explores some of the ways in which contemporary artists also grapple with this impulse to build a more sustainable future (whether or not they think this is actually possible). This exhibition does not survey all such efforts. Rather, it calls attention to a florescence of recent art making that resonates with the considerations at the heart of sustainable design. The project brings together thirteen artists and artists' groups based in the United States and Europe, leaving it to others to explore work coming from other parts of the world (sustainability seems likely to become a strong current among artists living and working in rapidly industrializing economies such as China's, for instance). It is important to note that environmental concerns are part of the mix of these artists' practices, but just that—they have no desire to be labeled as "eco" or "green" or even "sustainable" artists. They work in an expanded field, blending art, activism, and design to varying degrees. This exhibition focuses on only one strand of this art by presenting objects, structures, and processes/networks that use aspects of sustainable design to metaphoric, practical, speculative, ironic, and playful ends.

Green as the new black
About five years ago, I began to notice hybrid electric-gas cars on Chicago's streets. A few years later, a new logo cropped up at gas stations around the city: the green-and-yellow sunburst that introduced British Petroleum's new incarnation as self-proclaimed, eco-friendly "bp," purveyor not only of petrochemicals but also of solar power (their ad campaign initially touted their capacity to move "beyond petroleum"). Around the same time, the city government launched a campaign to make Chicago "the greenest city in America," and national magazines like *Dwell* began to feature eco-chic design strategies. This trend toward the greening of corporate practice, civic policy, and consumer desire has continued at a rapid pace. New advertising campaigns promoting eco-conscious corporate practices are rampant, and on a more personal level, we can purchase all kinds of goods for a green lifestyle much more easily than we could just a few years ago: even my decidedly gritty local grocery now sells organic milk.

What to make of all this green? Its return to (relatively) mainstream fashion—especially after a stretch through the 1980s and 1990s when environmental concerns languished at the fringes of social attention—might seem purely positive. However, if detached from a broader set of pragmatic and ethical considerations, green practices might be just another trend: a fleeting surface treatment rather than a deep and demonstrable good. (Activists, for instance, stay alert for "greenwashing," in which corporations highlight their environmentally friendly practices primarily as a public

relations device without significantly changing their overall business practices). Green tactics only address one strand of a complex problem. In these globalized times, a more holistic approach seems a sensible and necessary response to the deep interconnection among human activities and other "natural" systems.[2]

Sustainable design offers such an approach. It grows out of a broader set of policies and theories about sustainability that have developed over the past three decades. To meld two of the definitions that design historian Victor Margolin provides in his essay in this catalogue, sustainability involves meeting the needs of the present without sacrificing the capacity of future generations to meet their own needs, and doing so with equal attention to social and environmental justice.[3] Theorist Tony Fry prefers to think in less anthropocentric terms; he asks "is the essential project 'sustainable development' (the reform of the existing methods of development, but retaining its fundamental objectives) or 'the development of sustainment' (redirecting development toward a very different basis for the creation of economy, society, and a relation between human beings, the artificial worlds they create, and the biosphere)?"[4] Despite these differences of emphasis, both definitions underscore the need for change and the capacity for human action to enact it.

Sustainable design puts such thinking into practice by reimagining the ways we live and the stuff of daily life: *structures* such as offices, homes, and other buildings; *objects* such as tools, books, clothes, and cars; and *processes* and *networks* such as transportation and recycling systems. In doing so, it utilizes many established elements of green design, such as the use of recycled materials and renewable energy sources. But to reiterate, sustainable design posits that a purely green approach, which considers environmental questions in isolation from other factors, is incomplete and ineffective. Ethics have to be considered, along with a pragmatic attention to the entire life cycle of any designed thing from its production, through its useful life, to its disassembly and whole or partial reuse.[5] Although sustainable design practices are gaining toeholds in societies around the world through personal, civic, and even corporate efforts, the complexity of our current situation means that massive change is indeed necessary and only just starting to percolate in the face of many and persistent obstacles.

A sustainable art?
One can easily see how this sort of design might affect daily life. But how does it resonate with art making and particularly with the art presented in *Beyond Green*? At any given moment, artists have access to a relatively limited set of visual languages and conceptual strategies, picking up on or pushing against them. These must be considered along with the broader cultural context—the widespread desire for a more sustainable future—mentioned earlier.

During the 1960s and early 1970s, large numbers of artists began favoring ideas over objects and devising works for sites other than gallery and museum spaces. Growing out of this shift, and in tandem with wider phenomena such as the lingering effects of 1960s countercultural experiments and a growing sense of urgency around environmental problems, some artists began to pursue land art: environmentally based projects informed by conceptual and site-specific modes of art making. Earthworks—one variety of land art—consisted of works sculpted in (and in fact, from) remote or pastoral landscapes and often made no obvious environmental claims.[6] Other examples from this period were informed by more explicitly pragmatic and didactic purposes, focusing for instance on the impact of human development on particular ecosystems.[7] Since the late

1970s, increasing numbers of environmental projects have dealt not only with such out-of-the-way sites but also with towns and urban centers.[8] One common trait of these diverse works—apart from their engagement with environmental material—has been their emphasis on particular places.

Whether or not the artists in *Beyond Green* directly refer to these predecessors, their work must be considered in relation to and in distinction from them, and one key difference concerns this issue of site specificity. Many of the *Beyond Green* artists have worked in such modes, which remain a rich part of contemporary practice.[9] They also work, however, with a more nomadic sensibility exemplified by the mobile structures, objects, and processes/networks featured in this exhibition. Such works might have a generative connection to a particular spot, but they can mutate and adapt over time and in new places. Additionally, many address the contested spaces of contemporary cities and towns and thus might be seen as extending that strand of environmental work that emphasizes populated places rather than remote ones. Such projects chip away at perceptions that "the environment" is something "out there" and that cities are not as deeply connected to other ecosystems as they are to global trade networks. They reflect the current reality that as far-flung people and places become more entwined, ever-spreading populations and communications networks reduce the number of places that might qualify as "out there." (They also remind us that, for all their flaws, cities have some innate characteristics—for instance, the pooling of resources made possible by density—that can be amplified into sustainable spaces.)

In addition to site-specific and environmentally focused predecessors and parallels, the artists of *Beyond Green* should also be considered in relation to two aspects of European and American art during the 1990s that have an even more direct relationship to their work: the rise of critical practice and the fertile crossover between art and design.

Critical practice in art can be defined as an ethically based, conceptually grounded approach that addresses the social sphere from a position of critique and does so by embracing process as well as product and involving multiple constituencies, sites of production, and strategies for collaboration. As artist and critic Dan S. Wang writes,

> what critical practices share is a fundamental aspiration: to present questions and challenges about the way the world is, the ways we perceive it, and the ways in which we can act in it. These questions or challenges might be presented in general terms or with respect to a particular social detail or situation. This aspiration can be described as inherently critical, because the inescapable implication is that a world with different social arrangements, behaviors, or both is possible.[10]

Of course there is nothing new about that pull toward relevance, the impulse to grapple with the pressing questions of one's time and even to use creative endeavors as a means to enact social change. That desire recurs again and again in art, but it finds varied manifestations among different generations and situations.[11]

In the 1990s, new modalities of art making channeled the urge for social engagement into particular forms. As indicated above, collaboration has been an especially important vehicle. The last decade has seen the formation of many successful artists' groups

that address social questions not only by working with people outside usual art communities but also by forming collectives and thereby contesting or sidestepping traditional notions of authorship while also pooling resources. Equally important has been the spread of conversational and relational ways of working that derive their meaning in part from interactive processes. The latter have yet to be adequately addressed by historians and critics, but some important attempts have been made: art historian Grant Kester coined the term "dialogical art" for art that takes form not through objects but rather through platforms or processes meant to foster dialogue;[12] and critic Nicolas Bourriaud devised the influential term "relational art" to describe works that take on meaning largely through the participatory engagement of the audience.[13] Such modes of working are part of the wider artistic culture (and counterculture) of our moment, and though used by artists with differing aims, they have been particularly strong channels for critical practice, which has in turn been an especially fertile and increasingly visible presence within American and European art since the mid-to-late 1990s.[14]

During roughly the same period, design and lifestyle emerged as another major area of investigation for European and American artists, who expanded their practices by creating functional works that drew on the visual languages and materials of fashion, architecture, and interior and product design.[15] This blurring of boundaries paralleled the general ascendancy of design as a driver of desire within popular culture. Think for instance of the popularity of lifestyle magazines that cut across wide demographics, from *Readymade* to *Wallpaper* to *Martha Stewart Living*, the success of the Scandinavian retailer Ikea, or Target's promotion of itself as a low cost/high style purveyor of "design for all." Critic Hal Foster, among others, has unpacked some of the problematics of the infusion of design into so many aspects of contemporary culture, as we all become targets of increasingly focused niche marketing strategies aimed to infuse the "designed subject" with ever-greater consumer needs.[16] Some of the artists investigating design share his concerns or have looked away from consumerist drives and toward emancipatory ways of using design that draw on the utopian ideals of past moments of art/design overlap (the Bauhaus, the Constructivists) or more directly on progressive thinkers outside the art world, such as Buckminster Fuller or Victor Papanek, author of the 1972 classic *Design for the Real World*. The latter strand of practice has been especially important for *Beyond Green*.

In many ways the ascendancy of design and the rise of critical practice in art have been distinct developments; many artists exploring design as a site of investigation have no interest in engaging social questions, and many others working in a relational manner have little investment in making objects. The convergence of these two strands can provide rich opportunities for artists to create satisfying visual forms that provide new ways of embodying critical practices. And when this convergence occurs around environmental questions, it resonates strongly with sustainable design's goal of bringing social and aesthetic concerns together with environmental and economic ones.

Beyond green and into the museum

So what can we gain—or lose—by bringing these hybrid practices together within the particularly powerful framing space of the museum?

For museums to remain relevant, they must make space for projects that productively explore the tensions between the world "out there" and the protected precinct of the museum through works that provide rich experiences for visitors. In all its hybridity and occasional messiness, such work extends the boundaries of contemporary art in important ways. Museum exhibitions provide a means of introducing this work to wider audiences and, with luck, of securing a place for it within official records of art history. On a more practical level, through the commissioning of new projects and other kinds of support to artists, museum exhibitions can provide material resources and recognition that may be useful to the artists as they pursue their own independent projects.

Museums can themselves be strengthened by stretching to accomodate such art. Practices that perforate the boundary between the museum and the rest of the social sphere can make even the famously difficult white cube more responsive to current art and enticing to visitors of all kinds. When practitioners from different backgrounds come together to participate in exhibitions and accompanying programs, the museum becomes a platform from which to sustain existing networks and to create new ones. [Figure 1] Museums can also learn from art they present; in this case that means taking up the challenge to make museums more sustainable spaces.[17]

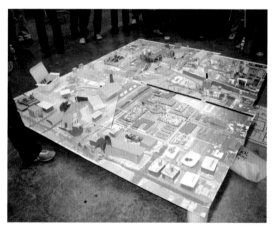

There are potential losses as well. The art presented in *Beyond Green* was for the most part planned with a dual commitment to its discursive and speculative function within the museum and its application in other arenas.[18] Still, some of the projects sit a bit more comfortably within the white cube than others, and there is always a risk that the museum setting could overdetermine the ways that visitors respond to these works. Indeed, other works that might fall under the heading "sustainable art" would not (could not) be appropriately housed in museums. Still, it is worth presenting works like these in spite of what is lost; the benefits—not the least being the potential for institutional change—outweigh the risks.

Who knows what will come next, and whether sustainable design will have a lasting impact on art making, museum practice, and the social sphere. Still, I find it heartening that space seems to be opening up both within the wider culture and inside the art world for practices that feel hopeful. Ironic detachment has its benefits (and indeed, appears within some of the works in this exhibition), but earnest engagement has a place and is finding expression within complex, experimental forms of contemporary production. The trick, of course, is not only finding ways to enact change in large and small ways but also finding the creativity, courage, and resources needed to sustain it over time.

FIG. 1
At a community design workshop held during *Beyond Green*'s opening weekend in Chicago, teams of exhibiting artists, community members, students, professors, designers, architects, planners, and others created this model, which shows playful and practical ways that sustainable design might be used to improve the built environment in an area adjacent to the University of Chicago's campus.

Thanks to my colleagues at the Smart Museum and iCI, and to Tony Fry, Peter Nicholson, Victor Margolin, and Dan S. Wang for sharing their responses to this text. I also thank Parkett *editor Cay Sophie Rabinowitz for commissioning a piece for the winter 2005 issue of* Parkett *that provided me with an initial opportunity to explore these ideas in print.*

1 See Bruce Mau, *Massive Change* (London: Phaidon Press, 2004).

2 Useful recent texts include Tony Fry, *A New Design Philosophy: An Introduction to Defuturing* (New South Wales University Press, 1999), Michael Braungart and William McDonough, *Cradle to Cradle: Remaking the Way We Make Things* (New York: North Point Press, 2002), and "The Death of Environmentalism: Global Warming Politics in a Post Environmental World," a 2004 paper by Michael Shellenberger and Ted Nordhaus that was commissioned by the Nathan Cummings Foundation and widely distributed over the Internet.

3 See Victor Margolin's essay in this volume, p. 21.

4 Tony Fry, email correspondence with the author, October 23, 2005.

5 Two popular conduits for ideas about sustainability, especially in relation to business, are *Cradle to Cradle*, (note 2) and Paul Hawkins, Armory Lovins, and L. Hunter Lovins, *Natural Capitalism: Creating the Next Industrial Revolution* (Boston: Back Bay Press, 2000).

6 Apart from the now ubiquitous *Spiral Jetty*, famous examples include Michael Heizer's massive sculptural excavation into a Nevada desert, *Double Negative* (1969), or Richard Long's performative work *A Line Made by Walking* (1967), in which he flattened a path through a grassy meadow and documented the results with a photograph. Some projects initiated in the 1970s remain works-in-progress, such as James Turrell's *Roden Crater;* these iconic forms of land art remain the most well-known manifestations of environmental work, receiving continued attention in the scholarly and popular press. Key texts include John Beardsely, *Earthworks and Beyond* (New York: Abbeville Press, 1984), Suzaan Boettger, *Earthworks: Art and the Landscape of the Sixties* (Berkeley: University of California Press, 2002), Jeffrey Kastner and Brian Wallis, *Land and Environmental Art* (London: Phaidon Press, 1998), and Gilles Tiberghien, *Land Art* (New York: Princeton Architectural Press, 1995).

7 For the former, think of Robert Smithson's unrealized plans of the early 1970s to remediate mining sites as a sculptural project; for the latter, Joseph Beuys's public tree planting, the *7000 Oaks Project*, first realized in Kassel in 1980, or Helen and Newton Harrison's gallery installations exploring watersheds.

8 Projects by Mel Chin, Mark Dion, Platform, Buster Simpson, Susan Leibovitz Steinmann, and Mierle Ukeles are just a few of the examples that could be mentioned here. The Cincinnati Arts Center's 2002 exhibition *EcoVentions: Current Art to Transform Ecologies* also explored this topic.

9 Critics such as Miwon Kwon and Claire Doherty have been useful in pushing the understanding of site-specificity; see Miwon Kwon, *One Place After Another: Site-Specific Art and Locational Identity* (Boston: MIT Press, 2004) and Claire Doherty, ed., *From Studio to Situations: Contemporary Art and the Question of Context* (London: Black Dog Press, 2004).

10 Dan S. Wang, "Practice in Critical Times: A Conversation with Gregory Sholette, Stephanie Smith, Temporary Services, and Jacqueline Terrassa," *Art Journal* 62, no. 2 (Summer 2003): 68-88.

11 Examples as varied as nineteenth-century painter Gustave Courbet, the early-twentieth-century Russian revolutionary Constructivists, artists affiliated with the Popular Front between the first two world wars, and the 1980s work of HIV/AIDS activists Gran Fury are just a few that might be cited here.

12 Kester uses one of the artists' groups in *Beyond Green*, WochenKlausur, as a primary example. See Kester, *Conversation Pieces: Community and Communication in Modern Art* (Berkeley: University of California Press, 2004).

13 Nicolas Bourriaud, *Relational Aesthetics* (Paris: Press de Racel, 1998).

14 This is partly a function of technological changes: the Web allows autonomous artists and artists' groups to form networks and share information more quickly than in the past so that groups like Temporary Services in Chicago can maintain an ongoing dialogue with artists, writers, and activists in Vienna, Copenhagen, Paris, or Portland. That same technology helped fuel the international antiglobalization and antiwar movements, which have produced ideologies and visual strategies that have often overlapped with critical practice, as demonstrated by *The Interventionists,* an exhibition curated by Nato Thompson at MassMoca in 2004. Shows like Thompson's are indicative of our situation within one of those recurring moments at which the broader art world has directed attention to socially engaged and activist practice through a developing critical and art-historical examination as well as through major museum exhibitions.

15 Some of the influential artists working in this manner include Atelier van Lieshout, Jorge Pardo, Tobias Rehberger, Joe Scanlan, Superflex, and Andrea Zittel. Such crossover has been documented through exhibitions like the Generali Foundation's *Designs for the Real World* (2002), the Walker Art Center's *Strangely Familiar: Design and Everyday Life* (2003), which focused on design but shares similarities with many of the practices featured in *Beyond Green*, and several design shows that have featured artists in *Beyond Green*, including the Cooper Hewitt National Design Museum's *Inside Design Now: National Design Triennial* (2003) and the Museum of Modern Art's *Safe: Design Takes on Risk* (2005).

16 See Hal Foster, *Design and Crime (and Other Diatribes)* (New York: Verso, 2002): 13–26.

17 I have taken this phrase from a symposium at which I discussed related issues, "Dual Commitment: Recent Examples of Public Art in Austria and the United States," organized by the artists Wolfgang Scneider and Beatrix Zöbl and held in various sites in Linz, Salzburg, and Vienna, July 2005.

18 To extend this thought, there are many ways to generate more sustainable museums: for instance, how might we devise more energy-efficient climate control systems, or bring sustainable thinking into the often wasteful practices of exhibition design, or do more to share resources and strengthen networks with other institutions or with our neighbors? Some of these changes would require major shifts, but others might be implemented more easily.

Reflections on Art and Sustainability

by Victor Margolin

The term "sustainability" has taken on varied meanings in the twenty-five years since it first came into use. In 1987, the World Commission on Environment and Development, headed by former Norwegian Prime Minister Gro Harlem Brundtland, defined it as follows:

> Sustainable development is development that meets the needs of the present without compromising the ability of future generations to meet their own needs. It contains within it two key concepts: the concept of 'needs,' in particular the essential needs of the world's poor, to which overriding priority should be given; and the idea of limitations imposed by the state of technology and social organization on the environment's ability to meet present and future needs.[1]

This definition appeared in the Commission's report *Our Common Future*, which was published fifteen years after the United Nations Conference on the Human Environment in Stockholm—the first in a series of international meetings on environmental concerns; fifteen years after the Club of Rome's seminal study *The Limits to Growth*; five years before the Earth Summit in Rio de Janeiro, which resulted in the document *Agenda 21: The Rio Declaration on Environment and Development*; and fifteen years before the last of the global United Nations environmental gatherings, Earth Summit 2002, which was held in Johannesburg, South Africa.

Because sustainability initially arose within the framework of international politics, it is a more pragmatic approach to overcoming social injustice and environmental ills than the idealistic ecological theories that include deep ecology, which stems from the writings of Norwegian philosopher Arne Naess; spiritual ecology, which puts a particular emphasis on the capacity to experience oneness with the planet; James Lovelock's Gaia movement; and social ecology, which emphasizes social organization and collaboration with nature.[2]

My own definition of sustainability follows in principle the statement in *Our Common Future* that "the strategy for sustainable development aims to promote harmony among human beings and between humanity and nature."[3] However, I choose to put the Brundtland Commission's connection between the social and the environmental into a sharper political focus by substituting the term "social justice" for "harmony among human beings" and "environmental justice" for harmony "between humanity and nature." Sustainability and the methods of achieving it are inherently political and, thus, contestable. Therefore, its definition should emphasize the need for struggle to achieve sustainable goals.

The culture deficit

In the various meetings and declarations on sustainability mentioned above, discussions of culture were nonexistent. The closest the United Nations came to the subject was the 1995 report *Our Creative Diversity*, which sums up the deliberations of UNESCO's World Commission on Culture and Development. The commission took up problems of culture within the broad context of economic and social development and consequently had little to say about specific cultural activities such as literature, music, or art.[4]

I was heartened to find the cultural question addressed in a recent essay by Hildegard Kurt, "Aesthetics of Sustainability," which appeared in a volume initiated by the German artist Herman Prigann.[5] Kurt argues that questions about the cultural and aesthetic dimensions of sustainability have lagged behind the debates on the topic that originated in the natural and social sciences during the mid 1980s. Though she does not refer directly to themes of human injustice such as torture, disease, and poverty with which artists have long been engaged, she does criticize the art world's limited view of sustainability: "In the art world," she writes, "lively dialogue is often hindered by the error of seeing sustainability only as an 'environmental subject' and not as a genuinely cultural challenge."[6]

Kurt also highlights the lack of cultural considerations in the sustainability discourse. "Anyone trying to find out why sustainability is not attractive as the task of the century," she writes, "will come across the 'culture deficit' inherent in the conception of the model. In fact you will largely look in vain for artists as protagonists of sustainable future development in the *Rio Declaration* and *Agenda 21*. And culture as an element in society, going beyond the arts and humanist education to include symbolic and aesthetic creative practice by individuals and societies, is scarcely mentioned either."[7] Given that discussions of culture, and especially art, are missing from the ecology and sustainability discourses of large international organizations and populist ecological movements alike, how does one begin to think about art's relation to sustainability such that a new understanding of artistic practice might result?

Sustainable art and its precedents

Before continuing to speculate on this topic, I would like to briefly review some of the art movements and projects that one might consider as sustainable art or precedents for it. The projects fall into several categories: art that engages with the land or landscape; art that incorporates sustainable practices such as recycling; and art that responds to social issues through the production of objects or discourse. Within the first category, artists have engaged with the land in different ways, not all of which can be seen as environmentally sustainable. Various terms such as "environmental art," "earth art," "land art," and "eco-art," have characterized these interventions. Walter De

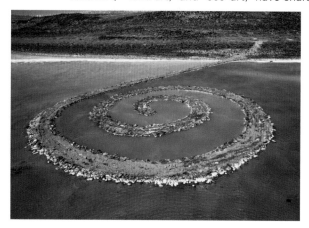

Maria's *Lightning Field* (1977), Michael Heizer's *Double Negative* (1969), Dennis Oppenheim's *Time Pocket* (1968), and Robert Smithson's *Spiral Jetty* (1970) [FIGURE 1] represent artists' intentions to alter the landscape, either by making cuts, gashes, or holes in its surface, forming new shapes from large masses of earth, stone, or other materials, or, as with De Maria's *Lightning Field,* filling a large field with metal rods lined up in symmetrical rows.

Other artists produce sculpted or constructed forms that they place in

FIG. 1
Robert Smithson
Spiral Jetty, April 1970
Great Salt Lake, Utah
Black rock, salt crystals, earth, and red water (algae)
3 x 15 x 1500 feet
Art © Estate of Robert Smithson / licensed by VAGA, New York, NY

the landscape to enter a dialogue with it. These include Mary Miss's *Sunken Pool* (1974) and Alice Aycock's *Circular Building with Narrow Ledge for Walking* (1976), the latter a structure that invites participation from the public. A third group of artists work with processes found in nature. Their projects are exemplified by Hans Haacke's *Ten Turtles Set Free* (1970) and Newton Harrison's *Slow Growth and Death of a Lily Cell* (1968). Related projects include Alan Sonfist's *Time Landscape* (1965–1978–ongoing) and Joseph Beuys's *7000 Oaks* (1982–87) [FIGURE 3].[8] Sonfist obtained the use of a land parcel on LaGuardia Place in New York City, where he planted trees and shrubbery that would have grown in the precolonial forests of the area, while Beuys's project, which he initiated in 1982 for documenta 7 in Kassel, Germany, involved reforesting the city of Kassel. One of the largest environmental art works ever executed, it was finally completed in 1987 after he died.

In recent years, art in the landscape has taken on a different meaning when it has been used to reclaim sites that were previously abandoned or even subject to some destructive force. To create *Wheatfield—A Confrontation* (1982), Agnes Denes planted and harvested two acres of wheat on the Battery Park landfill close to Manhattan. As a discursive act, the project demonstrated how a piece of wasteland could be brought back to life, although it ended without transforming the landfill permanently. In Germany, Herman Prigann, who created the *Terra Nova project* (1996–2000) to reclaim damaged or destroyed landscapes, turned Rheinelbe, a former coal mine area near Gelsenkirchen that had become a garbage dump, into an archeological field replete with traces of former buildings, stone sculptures, and a major landmark called the Skystair.

Recycling is another activity that contributes to a sustainable environment. Since the 1920s, making art out of previously used materials has been one of the significant strands of modernism, although until recent years it has not been framed by a discourse of ecology or sustainability. While Kurt Schwitters made hundreds of collages from the printed flotsam and jetsam of Weimar Germany, critics have never considered him to be an ecological artist. The same is true for John Chamberlain, who reclaimed cast-off auto bodies, which he crushed and shaped into large metal sculptures. On the vernacular side, the "muffler men" made by folk artists in the American Southwest or the toy cars, trucks, and motorcycles created by street artists in Tanzania and other African countries are also examples of industrial waste that is turned to productive use.[9] Mierle Ukeles, who has served for almost thirty years as

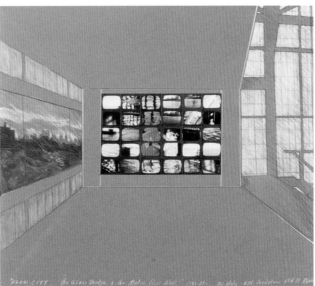

FIG. 2
Mierle Laderman Ukeles
Media Flow City from *Flow City*, 1983–present
Design for public art/video environment
at 59th St. Marine Transfer Station,
New York City Department of Sanitation

artist-in-residence at the New York Sanitation Department, dealt with the problem of waste a different way. In her project *Flow City* (1983–present) [FIGURE 2], she transformed a garbage-recycling unit of the Sanitation Department into a site where the public could observe how garbage is disposed of in actuality and on a video screen. As part of the project, she created a walkway, bridge, and viewing wall that were made of recycled materials.

Art that responds to social injustice is perhaps the largest category that might belong to a culture of sustainability, although it is scarcely visible as such since many artists make art based on social concerns without relating their work to sustainability issues. Within this category, for example, would be Joseph Beuys's well-documented and numerous political actions that include the information office he set up as part of his Organization for Direct Democracy (1971), his founding of the Free International University for Creativity and Interdisciplinary Research in Düsseldorf with the writer Heinrich Böll (1974), and his involvement in the genesis of the German Green Party (1979).

Art and sustainability

Three issues are central to the discussion of art and sustainability. The first regards form. If there is an "aesthetics of sustainability" (Kurt's term), then it should be based on something that art provides as a basis for aesthetic judgment. This need not be a physical object, or even an immaterial project. It might be a gesture or even a mental action. What forms, then, does art take in a culture of sustainability? Are they vastly different from the forms of art in mainstream visual culture, or are they sufficiently analogous to be easily understood in a new context?

Kurt's view of art in a modernist context leads her to characterize it as "a form of knowledge." This definition enables art to bring "aesthetic competence into the cognitive process—which makes it different from science and at the same time its equal."[10] Its not clear what antecedents in modernism's past Kurt is referring to when she characterizes art as knowledge, but one might imagine conceptual art, the Situationists, and some Fluxus activities as examples. Kurt believes that characterizing art as a form of knowledge can empower it discursively.

Once art is recognized as a cognitive medium, integrating aesthetic creative knowledge into the sustainability discourse would have a retrospective effect on that discourse, would change it. Art as a mode means that sustainability is seen, felt, thought, and conceived differently—and communicated differently.[11] Though Kurt's emphasis on art as a bearer of cognition brings it into relation with a discourse on sustainability, it does not clarify sufficiently what the boundaries of this discourse are, nor does it explain the contribution that art might make to it.

Adopting the broad definition of form that Kurt and others have provided leads to a second issue: art's relation to other practices that are concerned with sustainability. After recognizing art as a cognitive medium, how do we then distinguish its particular characteristics from those of architecture, landscape design, graphic design, community action, and additional activities that engage with problems of sustainability, especially when the projects appear to be similar?

A third issue is related to the second. How do we think about art that moves from discourse to action, art whose intent is to produce a useful result? And what about artists who generate ideas and plans rather than objects or actions? Are they planners

or artists, and by what criteria do we evaluate their work? In the never-ending debates on the difference between art and design, the distinction usually comes down to the primacy of discourse in artistic practice and the fact that artists need not be accountable, as designers are, to produce something useful. But when artists want to achieve social results without identifying themselves as designers, how should the critical community respond, and why is the artists' work given special status in a museum or gallery if its aims are predominantly practical?

Problems of interpretation

The widening of artistic possibilities in the last century has had positive results for the future of art and particularly for an art that engages with issues of sustainability. Besides the production of objects, two new elements have been added to artistic practice: participation and action. But these new possibilities have also created problems of interpretation that must be addressed before we can discuss further art's contribution to a sustainable culture.

Earth artists and environmental artists created projects that drew the spectator in as a participant. The experience of environmental art was immediate and more visceral than viewing a picture on a gallery wall. Environmental art expanded the sites of artistic display beyond the gallery or museum, and even the urban spaces of public sculpture. In Beuys's *7000 Oaks*, for instance, people were also invited to participate in planting the trees, not only to walk among them.

Beuys's project, like a number of others, spills over into the realm of action and raises questions about how to determine its aesthetic value. Reforesting Kassel was an ecological gesture to redress the balance of nature in the urban landscape. Though initiated by an artist, it transcended art discourse and became social action. So did a series of similar projects by artists in the United States and Europe. Consider Harriet Feigenbaum's land reclamation work, *Erosion and Sedimentation Control Plan for Red Ash and Coal Silt Area—Willow Rings* (1985). On a site damaged by strip mining, the artist planted two concentric circles of willow trees around a pond that was formed from coal-dust run-off. The site became a public park that also preserved the memory of the land's prior use. Similarly, Bonnie Sherk founded The Farm in 1974, bringing together an interdisciplinary team to create a sustainable ecosystem and educational park on a piece of unused land near a

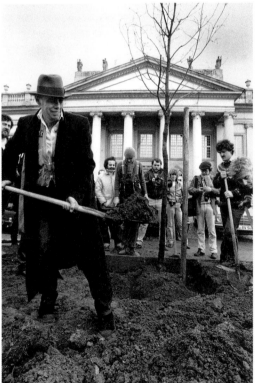

FIG. 3
Joseph Beuys plants the first tree for the *7000 Oaks* project
at documenta 7, 1982, Kassel, Germany

San Francisco highway interchange. Finally, Mel Chin's *Revival Field* (1990–93) at Pig's Eye Landfill in St. Paul, Minnesota, became a biological experiment in which the artist explored the use of plants to remediate the soil in a landfill that had been contaminated by heavy metals.[12]

Formal qualities are easy to identify in the projects by Beuys, Sherk, or Feigenbaum, where we are looking at configurations of materials, whether artificial or natural, in patterns. But what about Chin's research on plants to remediate contaminated soil? Where is the aesthetic dimension? In the ethic of Chin's intention? In the ingenuity of his concept? In the physical arrangement of the plants? The challenge here is difficult, as it is in other eco-art projects. Critics generally evade the interpretive problem by considering such projects within existing categories such as environmental art or land art and then loading a set of prior aesthetic conventions onto them.

And what is the ecological aesthetic of Beuys's Social Sculpture? It has been described as a shift from museological concerns about the context of art to anthropological ones. "Creativity, to him, was a science of freedom. All human knowledge comes from art; the concept of science has evolved from creativity. And so it is that the artist alone is responsible for historical awareness; what counts is to experience the creative factor in history. History must consequently be seen sculpturally. History is sculpture."[13] The concept has even been institutionalized in the Social Sculpture Research Unit, directed by artist Shelley Sacks at Oxford Brookes University in England. Sacks, who worked with Beuys, describes the projects initiated there as "instruments that involve 'trans-actions' between people, issues and places. They are arenas for negotiation, creating shared currency and new forms of dialogue."[14] What, then, is the basis for an aesthetic judgment? Is there a form to the organization of the workshops that invites aesthetic consideration? The central focus of the projects appears to be the creation of an experience for the participants. While Sacks does not present the projects as artworks, they derive from Beuys's intention to collapse the proverbial boundaries between art and life.

Critics have worked hard to fit Beuys's projects and others like Alan Sonfist's *Time Landscape* or Newton and Helen Harrison's *Portable Farm: The Flat Pastures* (1971–72) into an art discourse when, in fact, the projects sometimes have more to do with other practices such as landscape architecture, design, or even biology. Part of the problem is that many artists want to participate in social processes or make statements about social situations in ways that transcend the conventional forms of representation that museums and galleries were originally created to house. Even as their projects avoid the commodity forms on which the art market depends, they are sometimes led to produce documentation that nevertheless conforms to the conventions of museum and gallery display as well as to the commodity demands of the art market.

Problems of identity

Once artists enter the realm of action, it is difficult to characterize their projects differently from those of other actors such as landscape designers or even architects. In a recent exhibition, *Groundswell*, at the Museum of Modern Art, a group of exemplary landscape designs were presented. What differentiates them from the previously described environmental projects is that they dealt primarily with postindustrial urban landscapes.[15] The museum's architecture and design department organized the

exhibition, thus preserving the conventional distinction between the practical and the discursive arts. What MoMA's departmental division fails to acknowledge, however, is that the discursive has spilled over into the practical and the practical has become more discursive. The landscape projects have as much to do with art discourse as artists' action projects do with design. The prevailing division between art and design practice is one of the biggest obstacles to holistically envisioning a new sustainable culture and remains a challenge not only for museums, but also for artists and practitioners.

Let us return for a moment to Hildegard Kurt's intention to discover an "aesthetics of sustainability" and her claim that in order for art to function as a cognitive medium, it must be "seen, felt, thought and conceived differently." Although we recognize that culture consists of multiple discursive modes that complement each other's ability to describe, explain, or even represent experience, defining the boundaries of those modes has become increasingly difficult. By separating art too rigidly from complementary practices that engage the same issues and situations, one runs the risk of maintaining a misleading cultural hierarchy in which art projects are understood to carry a heavier discursive load than more pragmatic designs. Thinking this way, however, often minimizes the discursive power in a practical design project.

Artists who call attention to social or environmental problems sometimes garner more notice and public interest than the people who are engaged directly with such problems. For a recent exhibition of his work at Chicago's Museum of Contemporary Art, artist Dan Peterman was invited to build three shed structures—a bicycle repair shop, a marketplace/classroom kiosk, and a garden shed—using standard waste containers. Two were relocated to a local park during the exhibition and adapted for a variety of cultrual uses. However, the kiosks received more public attention and occupied more discursive space as art than as design. Had such kiosks been placed in the park directly, they might have merited a mention in the newspaper but not gained the cultural capital they accrued as works of art. By presenting his kiosks in an art exhibition, Peterman performed a service in that he called the need for such structures to public attention, and one could well argue that he used the cultural capital of art's discursive power to call attention to a social need.

Nonetheless, the hierarchy between art, architecture, design, and planning remains a paradox within the culture of sustainability, where the principal criterion of value is to bring into being sustainable projects and environments. The social space for the demonstration of such projects is still coded unsustainably according to discursive hierarchies that privilege some practices over others. This would be less of a problem if the formal manifestations of each practice were sufficiently distinct, but as these formal distinctions break down, we need to open up the discourse about projects to create greater continuity between them.

What gets lost when a cultural hierarchy of practices prevails is the wider knowledge of projects that do not fit easily into an art-world or museum framework. I think here of the many productive ideas that resulted from research at Nancy Jack Todd's and John Todd's New Alchemy Institute, particularly their "living machines" that have been successfully used for water treatment and other purposes but also their ecological designs for urban spaces—hydroponic factories, back lot bioshelters, and bus stop aquaculture designs.[16] These are equivalent to work that some artists have carried out, but they have not been linked to related projects in the art world.

A strategy for a sustainable future

Beuys was instrumental in creating the current difficulties that surround the problem of "ecological aesthetics." He was strategically brilliant in trading on his recognition as a gallery artist to gain attention for his action projects such as *7000 Oaks* and the polemics of his lecture tours. Ultimately all these activities have been drawn into an art discourse, but they don't fit comfortably. To deal with new forms of human expression and action, critics and curators are continually trying to stuff them into institutional boxes where they don't fit. Old categories need to collapse before we can begin to create a different dialogue on aesthetics in a sustainable culture.

We will need a new aesthetic to embrace the three categories of object, participation, and action without privileging the conventional formal characteristics of objects. In this aesthetic, the distinctions between art, design, and architecture will blur as critics discover new relations between the value of form and the value of use. Hildegard Kurt was correct when she criticized the art world for viewing sustainability in terms of environmental subjects instead of as a larger cultural challenge. The culture that Kurt identified within the wider sustainability discourse remains an issue and needs to be overcome. This will lead to new forms of solidarity within the culture of sustainability.

Imagination is an artist's greatest asset. It can produce bold visions of what a sustainable future might be like. People can be moved and aroused by powerful environments, innovative designs, and practical demonstrations of active engagement. With open minds and a willingness to collaborate, those who seek a place in the culture of sustainability must move forward. The problem of "ecological aesthetics" will solve itself.

1 World Commission on Environment and Development, *Our Common Future: World Commission on Environment and Development* (Oxford and New York: Oxford University Press, 1987): 43.
2 For a discussion of the major ecological theories, ideologies, and movements, see Caroline Merchant, *Radical Ecology: The Search for a Livable World* (New York and London: Routledge, 1992).
3 *Our Common Future*, 65.
4 *Our Creative Diversity: Report of the World Commission on Culture and Development* (Paris: UNESCO, 1995).
5 Hildegard Kurt, "Aesthetics of Sustainability," in *Aesthetics of Ecology: Art in Environmental Design, Theory and Practice*, ed. Heike Strelow in cooperation with Vera David, initiated by Herman Prigann (Basel, Berlin, and Boston: Birkhäuser, 2004).
6 Ibid., 239
7 Ibid., 238.
8 I have taken the breakdown of project types from Mark Rosenthal's essay, "Some Attitudes of Earth Art: From Conception to Adoration," in *Art in the Land: A Critical Anthology of Environmental Art*, ed. Alan Sonfist (New York: Dutton, 1983): 60–72.
9 See Timothy Corrigan Correll and Patrick Arthur Polk, "Muffler Men, Muñecos, and Other Welded Workers: Occupational Sculpture from Automotive Debris" and "Streetwise: The Mafundi of Dar es Salaam," in *The Cast-Off Recast: Recycling and the Creative Transformation of Mass-Produced Objects* (Los Angeles: UCLA Fowler Museum of Cultural History, 1999): 31–80; 81–110.
10 "Aesthetics of Sustainability," 240.
11 Ibid.
12 The projects by Beuys, Feigenbaum, Sherk, and Chin are documented in *Landscape and Environmental Art*, ed. Jeffrey Kastner, survey by Brian Wallis (London and New York: Phaidon Press, 1998).
13 Heiner Stachelhaus, *Joseph Beuys*, trans. David Britt (New York, London, and Paris: Abbeville Press, 1991): 64.
14 Shelley Sacks, "Performing an Aesthetics of Interconnectedness," in the ongoing online exhibition *EnterChange: Performance and Nature*, curated by Wallace Heim for Green Museum, 2004, http://www.greenmuseum.org/ c/enterchange/artists/sacks.
15 See the review by Nicholai Ourousoff, "Confronting Blight With Hope," *New York Times*, Feb. 24, 2005.
16 An excellent introduction to the Todds' work is Nancy Jack Todd and John Todd, *From Eco-Cities to Living Machines: Principles of Ecological Design* (Berkeley: North Atlantic Books, 1994).

ALLORA
&
CALZADILLA

Opposite: *Under Discussion*, 2004–05 (detail)
Single channel video projection with sound
(CAT. 2)

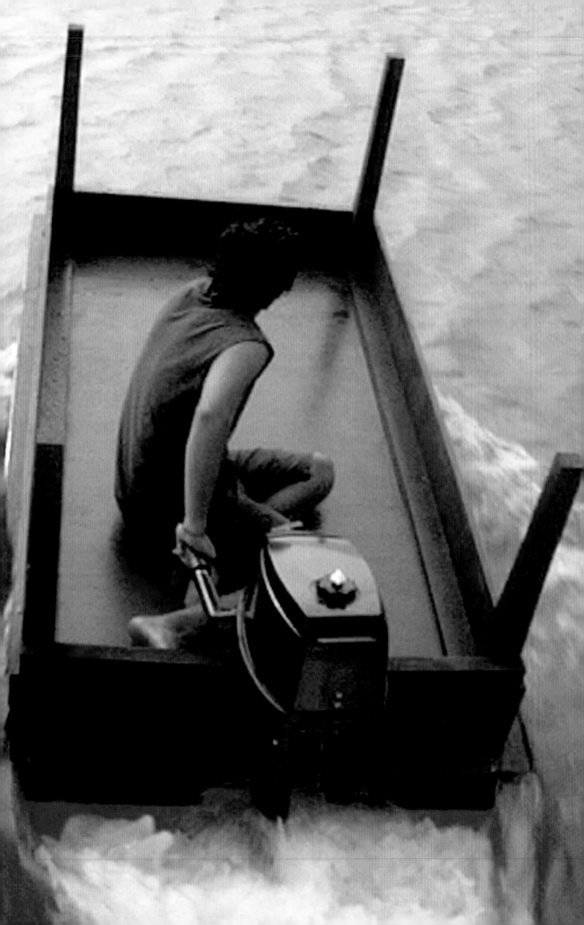

Several recent projects by

Allora & Calzadilla (Jennifer Allora and Guillermo Calzadilla) have brought a poetic sensibility to bear on the complex intersections of power, activism, and environmentalism within the landscape of Vieques, a small island off the coast of Puerto Rico. Vieques has been—and remains—disputed terrain. After decades of effort by local and international activists, the US military stopped conducting its notorious bombing exercises on Vieques in 2003. The land is now managed by the US Department of the Interior, a shift that raises a new set of challenges for Viequenses who wish to preserve space for themselves in the face of plans for tourist developments and intensive environmental preservation.

Allora & Calzadilla are represented in *Beyond Green* by two recent projects that address sustainability in Vieques. Each of these videos follows a young man traveling around the island on a modified vehicle: an everyday object that the artists have transformed for evocative new uses. In each case, Allora & Calzadilla intercut close-ups of the rider and vehicle with wide or aerial shots that situate these unusual journeys within the contested landscape of Vieques, in which verdant open spaces, homes, military installations, and protest graffiti comingle.

In *Returning a Sound* (2004–05), Homar, an activist, rides around Vieques on a moped that Allora & Calzadilla reengineered by attaching a trumpet to the exhaust system. During the ride, every thrust of the throttle or shift in speed alters the instrument's pitch. Allora & Calzadilla have edited out other ambient noise, leaving only the alternately sputtering vibrato and clear, pure sound of the trumpet as a jazzlike soundtrack, a call to action, or perhaps an anthem, as the artists discuss in the interview that follows.

Under Discussion (2005) features a special boat, a simple wooden table that Allora & Calzadilla flipped upside-down and enhanced with a motor. The video's protagonist, Diego, circumnavigates the island on this craft, a witness to Vieques's uncertain situation as well as an actor in determining its future as he moves the discussion into surreal waters. The table has become a vehicle—a means to get somewhere—and also a stand-in for other tables around which those seeking to resolve Vieques's future have gathered. As Yates McKee has noted, however, such tables are imperfect vehicles. "In liberal thought, 'sitting down at the table' suggests an ideal space of conflict-resolution through rational dialogue [...] Yet this ideal fails to account for the inequalities that underwrite the space of the table to begin with, such as the hierarchical division between scientific expertise and local ecological knowledge, which rarely register at all in planning processes. *Under Discussion* is an experimental device for publicizing such counter-knowledge."[1]

1. Yates McKee, "Allora & Calzadilla's Recent Videos: *Returning a Sound* and *Under Discussion*," unpublished manuscript, 2005.

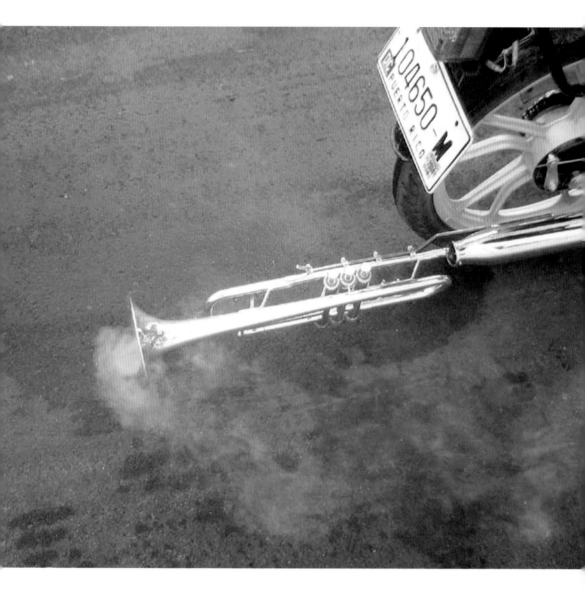

Returning a Sound, 2004 (detail)
Single channel video projection
with sound
(CAT. 1)

Interview

Stephanie Smith: You will be showing two short videos in *Beyond Green*, both of which deal with Vieques, a small island off the coast of Puerto Rico. That particular location and its shifting environmental, social, and political conditions is crucial to your project. Could you talk about the background?

Allora & Calzadilla: Vieques is an island off the mainland of Puerto Rico used for the past 60 years by the US Military and NATO forces to practice military bombing exercises. The civil disobedience movement on the island, along with the active protest movement and various civic initiatives by Viequenses and an international network of support, led in May of 2002 to the stopping of the bombing, the removal of the US military forces from the island, and the beginning of the process of demilitarization, decontamination, and future development. When the civil disobedience movement succeeded in removing the US military from the island in 2003, the land changed ownership from US military property to the ownership and management by the US Department of Interior, Fish, and Wildlife Services. This shift in management has created a stalemate for the civic initiative organizations on the island, who are demanding that their land be decontaminated of all toxic substances and unexploded ordnance and ultimately be restored to municipal jurisdiction and management.

SS: Please describe the two video works that will be in the exhibition, starting with the earlier piece, *Returning a Sound*.

A&C: *Returning a Sound* was made after the military lands were finally opened to the public in May 2003. We were thinking about how this celebratory moment, in which the civic movement enjoyed a momentous victory, was also quite a precarious time, as the ultimate fate of the land was still uncertain. We became interested in the idea of an anthem as a commemorative structure, but we were not satisfied with the conservative connotations of the word, its uses and abuses. We preferred the more open set of associations that the Greek etymology of the word offered: *antiphonos*, sounding in answer, and *anti-*, in return. We wanted to create a gesture that would at once proclaim loudly the achievement of the civic initiatives yet would call to attention the new stakes of the movement.

Our video, *Returning a Sound*, follows the path of Homar, a civil disobedient, moving throughout the island on his moped. The muffler of his bike has been altered from an apparatus used to silence the noise produced by the motor to an instrument, a trumpet, used to produce a loud resounding call, a call to attention and to action, as the island now is entering a transitional period between destruction and recovery and a new era of imagining its future development.

SS: What about *Under Discussion*?

A&C: The present state of the land in Vieques is under discussion. Facing challenges in many ways far greater and complex than the demilitarization campaigns, the citizens of Vieques are currently entrenched in a mire of bureaucratic, administrative, legal, and political debates concerning the fate of their island. This film follows the son of a local fisherman involved in the Fisherman's Movement, a key movement in the 1970s that initiated the civil disobedience movement on the island. He has converted the discussion table, by turning it upside down, into a boat, and is driving it along the coastal areas of the island where the land status is still contested. Mobilizing the discussion table

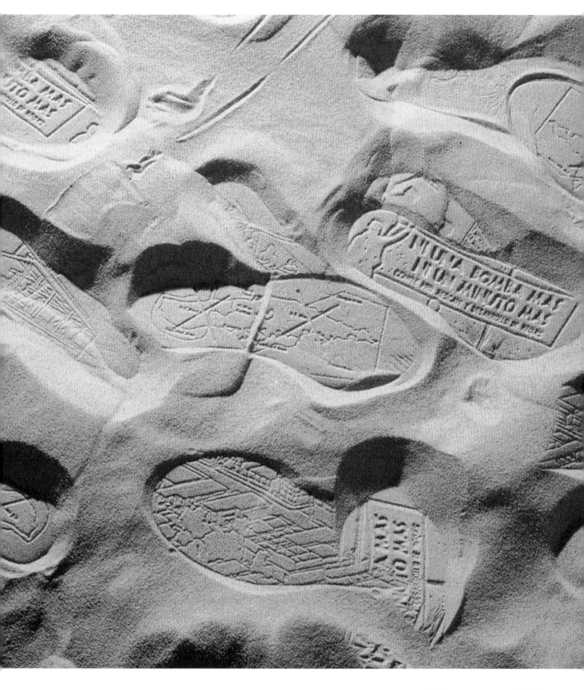

Landmark (foot prints), 2001–04 (detail)
Digital c-print

through its conversion into a fishing boat, the protagonist takes the debate into new, unexpected directions.

SS: *Under Discussion* was just included in the Venice Biennale. Was it your choice to show the piece? If so, why did you select it for that context?

A&C: Yes, we chose to show the work for a number of reasons, starting first with the site of the Biennale in the Italian Naval Arsenale. Shown in that context, the video opens up to crosscultural and transhistorical references, as the subject of militarism, conquest, and empire have played a central role throughout civilizations and histories. The video considers what happens to former military land. Showing it in the context of a large-scale international art exhibition housed in a former navy property confronts the viewer with one possible outcome, a site for cultural production, while hopefully critically opening that space up to its own form of interrogation, perhaps leading the viewer to question, among other things, the role culture plays in such transitional spaces, what it permits and what it excludes. Another, more pragmatic interest of ours was to expose the situation in Vieques to a large international public. With no interest in instrumental-ization, we hope this work expands the network of solidarity and support for the people of Vieques and the global demilitarization movement in general. One of the reasons for the success of the peace and justice campaign in Vieques was its ability to reach out to a global network of supporters who have both contributed to and learned from the ini-tiatives in Vieques. So for example, you find people in a village in South Korea who call their town "The Vieques of Korea" and are using tactics similar to those that were used in Vieques in their own resistance to bombing exercises in Maehyang-ri. Or a conference organized in Glasgow, Scotland, entitled "Lessons from Vieques—a Conference Celebrating Peace, Resistance and a Commitment to a Military-free Scotland" (April 2005). There were also 9,000 protesters marching in Fretzdorf, Germany, on March 27th, 2005, for the struggle in Vieques. Our intention in showing *Under Discussion* in Venice was to establish yet another link in this larger global network of solidarity and support.

SS: As I've watched *Under Discussion*, I can't discern whether the table/boat is actually on the water or if it's a very clever digital manipulation. That ambiguity seems interest-ing—maybe a reflection of the instability and murkiness of the whole situation on Vieques—but at the risk of killing the mystery I'm going to ask anyway. Did the table actually work as a boat?

A&C: Yes.

SS: Do the objects—the table/boat and the altered moped—still exist? Do you have any interest in them as sculpture or design apart from their use within these videos?

A&C: Both the table/boat and the altered moped are still in Vieques. The last time we checked, the table/boat was still in the harbor in Esperanza, the small town on the south side of the island. It was being used as a dinghy by the fisherman to go out to their larg-er fishing boats in the harbor. Homar still has the moped and uses it to get around the island, but the last we heard the trumpet fell off, so it's back to being a regular muffler.

SS: As a technical note, are there any particular display parameters for your video works? Do you think about them as installations? Do they need to be screened as pro-jections, at a particular scale?

A&C: We prefer for these two particular videos to be projected. It underscores the mon-umentality and weight of the situation the protagonists find themselves in, even if their activities are repetitive or mundane—i.e. driving a moped or a boat—and it foregrounds the land as the arena in which these antagonisms are staged.

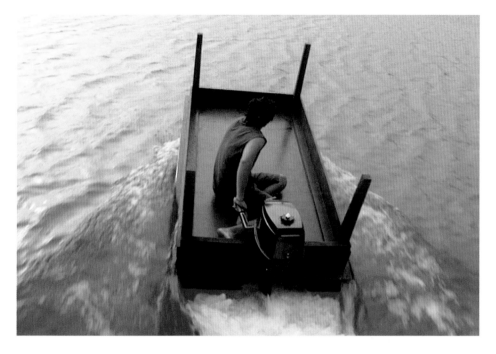

SS: The central figure in each video makes a perambulation around the island: either by land or by sea he ends up right back where he started. That seems a bit pessimistic: it suggests a condition of stasis that runs counter to the trumpet's call for action although perhaps is more in keeping with the protagonists' roles as witnesses/observers.

A&C: We see this cyclical movement a bit differently. The idea for the protagonists' particular trajectory was for it to function as a kind of mapping. In *Returning a Sound*, Homar travels through those tracts of land that in his lifetime and in the generation before him had never been accessible. In the expropriations of the 1940s, thousands of families living throughout the island were forced off of their land and made to either leave together or to settle in a small wedge of land in the island's center. The military occupation of the island divided the geography into three sections. In the west was the ammunition storage facility and in the east was the life-firing range. In between was the civilian population. So in *Returning a Sound*, Homar begins his journey in the civilian area in the central northern town of Isabel II and then moves in a clockwise direction around the entire island. With his modified bike, he starts in the town and then moves into the military lands. A similar logic holds true for *Under Discussion*. In this instance, Diego starts in the central southern town of Esperanza and moves eastward along the fishing routes that were the contested grounds of the Fisherman's Movement, which initially bore witness to the devastating effects of the bombing. Since both of their actions took place within a certain temporality, we understand that the protagonists do not really arrive *exactly* where they started. Time has passed—both the protagonist and his environment in which his action took place are somehow, even if only slightly, different. It is more of a spiral than a circular movement. This understanding of time and transformation, in a certain manner, reflects the ecological nature of the peace and justice

Under Discussion, 2004–05 (detail)
Single channel video projection with sound
(CAT. 2)

movement in Vieques, in which change happens slowly, across generations, yet also respects and acknowledges the contribution of all actions, however great or small, in the eventual transformation of place.

SS: These works followed another project in Vieques, an interrogative design, intervention, and photography project called *Land Mark*, which you made prior to the military pullout from the island.

A&C: The photography project—which we have shown in various exhibition contexts—is an extension of a series of actions that took place in Vieques in 2001-2002. We worked in collaboration with activist groups involved with protest actions in the disputed US Navy bomb testing range. Initially our project consisted of designing custom-made soles that were added onto the shoes of people involved with the land reclamation campaign. The shoes were used in civil disobedience actions in which people seeking to reclaim the land entered the range and, as a result of walking in that landscape, marked their presence in the form of a stamp on the terrain. The images on the bottom of the shoes, chosen by each individual user, depicted territories (geographical, bodily, linguistic, etc.) that functioned as counter-representations of the site's function at that time as well as what it is still to become.

SS: You've done other works that touch on sustainability but not on Vieques in particular, some of which we considered including in *Beyond Green*. However they ended up being too delicate or logistically complex to travel with the show. There was something apt about the perversity of trying to include works that would have consumed large amounts of money, time, and resources. Although we decided not to pursue those options in the end, the process highlighted the difficulties of trying to address sustainability within the logistics as well as the content of an exhibition. Could you describe two of those pieces that we considered—*Puerto Rican Light* (2003) and *Ten Minute Transmission* (2003)?

A&C: For *Puerto Rican Light* we collected the sunlight from Puerto Rico using portable photovoltaic cells. The light was stored in a battery bank and used to provide the energy

Ten Minute Transmission, 1998–03 (detail)
Metal wire hangers and ham radio
Installation view at Tate Modern, London

for the fluorescent light sculpture by Dan Flavin, *Puerto Rican Light (to Jeanie Blake)* (1965). Enough sunlight was collected from Puerto Rico to power the Dan Flavin sculpture for the course of an exhibition.

Ten Minute Transmission consists of an antenna made from hundreds of metal wire hangers, forming a replica of the International Space Station (ISS). This precarious/ fragile construction is suspended from the ceiling and is meant to be used to contact the ISS. During the ten minutes when the space station is in transmittable orbit above the exhibition location, the sculpture/antenna attempts to make two-way contact with the astronauts. This is done through the use of a ham radio and a computer program that automatically dials the ISS every 90 minutes, the amount of time it takes the space station to orbit the earth. In the time between attempting contact, the antenna functions as an international radio station capturing other ham, fm, and am radio signals coming through the air (locally and internationally) that are made audible to the passing public.

However, our interest in this work is not reducible to sheerly technical or functional criteria. It is comprised of an unnatural composite of elements—political, technological, and sculptural—that would normally never be brought together. We wanted to evoke Vladimir Tatlin's *Monument to the Third International* (1919, designed to have a gigantic radio tower) but also to draw attention to the exclusionary conception of "the international" that surrounded another engineering project with universal pretensions, the ISS, a paramilitary complex floating outside the earth. Despite its name, the ISS is controlled by a handful of powerful nations in the global north; this poses a big political question about who gets to be represented in the extraterrestrial realm. On its own, this dialectic would make an interesting historical and political point, but it would not be monstrous. Coat hangers are a debased, cast-off material, part of an economy of the scavenger. They are detritus with an infinite capacity to be reused for purposes other than those prescribed by their original design. They are ciphers of the potential monstrosity that haunts the utopian plans of "mankind."

SS: How do you see these works fitting into the questions about sustainable design raised by *Beyond Green*?

A&C: Our works included in this exhibition in particular look at the question of environmental justice—what and who counts as an endangered species—and how this discourse reconceptualizes the relationships between nonhuman and human nature and, as a result, fosters new forms of environmentalism. The land-rights struggle in Vieques extends the parameters of the term sustainability to include the very survival of the indigenous civilian population of the island, and, as a result, complicates and broadens mainstream notions of environmentalism and sustainability to include questions of social justice that affect how people live in their environments. The recent transition of the contaminated naval grounds into a wildlife refuge administered by the US Department of the Interior and the rapid development of mostly North American tourist initiatives further complicate this debate. The former mask grave health problems caused by the release of toxic chemicals from the hundreds of thousands of bombs dropped over the past 60 years on this small island and the latter continues a long history of colonization and systematic exclusion of the local population from the natural and productive resources of the island.

June 2005

FREE
SOIL

F.R.U.I.T., 2005 (detail)
Digital graphic
(CAT. 3)

Free Soil, formed in 2004,

is a collaborative group of artists, activists, researchers, and gardeners with a shared interest in "projects that reveal social, political, cultural, and environmental relationships." They are particularly interested in the interrelationships among cities and other ecologies, the environmental impact of urban development, and progressive uses of urban space. (The team working on *Beyond Green* includes new media artist Amy Franceschini, founder of the artists' group Futurefarmers; artist and interaction designer Myriel Milicevic; and artist and radical gardener Nis Rømer.) Free Soil brings the interdisciplinary skills of its members to bear on multimedia projects that include sculpture, gallery installations, public projects, gardens, workshops, and Web-based new media technologies. Free Soil's projects combine a friendly, even playful design sensibility with activist pedagogy; they believe "art can be a catalyst for social awareness and change."

F.R.U.I.T. (Fruit Route User InTerface, but an open acronym), Free Soil's new project for *Beyond Green*, explores the networks that link cities and agricultural areas and highlights the costs (social, economic, environmental) of getting fruit from rural farms to ever-growing urban populations. Franceschini, Milicevic, and Rømer have conducted research to trace the paths that fruit takes as it travels from farms to urban fruit stands. Focusing on the orange—a fruit they chose for its sturdiness and the ease with which it can be shared among a group of people—they have compiled stories and statistics that reveal the environmental and social impact of its journey to market. With its tagline "The Right to Know!", *F.R.U.I.T.* encourages people to learn about where their food comes from and to support local agriculture.

The project combines an ongoing public art initiative with an installation that makes the public component tangible within the gallery space. The installation centers on Free Soil's re-creation of a fruit stand: a bit of vernacular design that one might find in any urban street market, laden here with fake oranges rather than actual produce. The "oranges" are wrapped with printed sheets that combine playful graphics with concrete information about Free Soil's "The Right to Know!" campaign. Visitors are invited to take one wrapper from a dispenser included in the installation. The wrappers (also available in digital form on Free Soil's Web site) can be used to wrap fruit in one's own local grocery or fruit stand and leave it for others; this gentle intervention makes use of existing networks to spread information and raise awareness. The gallery presentation also includes prints that convey Free Soil's ideas and an interactive computer station that links to the interactive *F.R.U.I.T.* Web site. These components of *F.R.U.I.T.* unpack the elaborate processes that undergird an everyday act of consumption. Like all of Free Soil's projects, *F.R.U.I.T.* is a conduit for learning, and through it they hope to raise awareness about urban gardening and other alternative food movements as instruments for change.

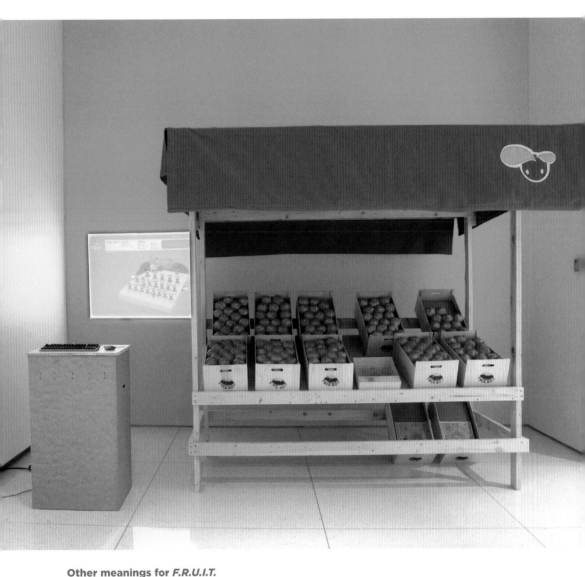

Other meanings for F.R.U.I.T.
Fruit Route Under Intense Transit
Finding Routes Using Itinerate Technologies
Following Routes Using Itinerate Technologies
Following Routes Using Internet Technologies
Fostering Rural Urban Itinerate Technicians
Fossils of Rural Urban Illusionist Transportation
Fiction Revealed Using Instruments of Truth
Fruit Route Use Intertwine Transit
Fruit Reveals Unintentional Interventionist Truth
Fruit Reveals Unadorned Instant Truths
Fruit Reveals Unexpected Instant Truths

F.R.U.I.T., 2005
Interactive installation with wood, cloth awning,
wood boxes, styrofoam, paper wrappers,
computer equipment, and three Iris prints
Installation view at Smart Museum of Art,
University of Chicago
(CAT. 3)

Interview

Stephanie Smith: You've only been working together as Free Soil for a year. Please tell me a bit about each of your backgrounds, why you decided to form this new artists' group, and what you each bring to the collaboration.

Free Soil: Free Soil sprouted during a workshop in Lofoten, Norway, which focused on media in relation to site. Four of us (Amy Franceschini, Nis Rømer, Stijn Sciffeleers, and Joni Taylor) came together during this workshop and found that even though we were working in geographically distant places, we shared references and were all interested in the environment and in participatory art forms. We found there that we all had aligned interests in the economic, social, and political organization of space. We wanted to make a milieu for exchange and learning together, so to facilitate this for ourselves we made the Web site www.free-soil.org, which is also a public resource. We formed this umbrella group with a hope that we would continue the discussion we had started in Norway. Our interests really stem from wanting to learn and propose alternative methods of research, collaboration, and learning.

Free Soil has grown to include other members. Three of us are working on the project for *Beyond Green*: Amy Franceschini is an artist and educator dealing with notions of community, sustainable environments, and a perceived conflict between humans and nature. She founded Futurefarmers in 1995 and continues to maintain a balance between art and design. Currently she is teaching art at Stanford University and San Francisco Art Institute. Myriel Milicevic is from Germany and has just completed a masters degree in Interaction Design, a new field that concentrates on human involvement when designing for telecommunication technologies, interactive products, and services. She has combined mobile game playing with sensing technologies so that everyday people can explore their environments in a fun and informative way. Nis Rømer comes from Denmark and works with public art in the city, on the Web, and in the news media. He studied urban planning at The Berlage Institute (Netherlands) and has a special interest in the social and political organization of space and in how processes of globalization affect the city and our natural environment.

SS: What do you each find most interesting or satisfying about working as part of this collective?

Nis Rømer: Apart from being able to share resources, being a part of a community allows you to test your ideas, which is useful when working in the social sphere.

Amy Franceschini: I like to think of Free Soil as a mother ship: a free-floating and open-source system of activities and resources that lands on occasion. We all have an interest in sharing our resources and collectively questioning the social and political landscape that surrounds us. At this point, we try to stay as open as possible.

Myriel Milicevic: Looking simultaneously at the same issues from remote places is quite interesting—we can compare patterns and behaviors between different locations, and often their conditions are linked to one another.

SS: You live in three different countries and only occasionally get to work together face-to-face—that's one of the reasons we're doing this interview by email. I'm curious about how that shapes the dynamics of your creative process.

FS: Since Norway, we have collectively met in person twice. Once Nis hosted us in Copenhagen, and another time Amy hosted in San Francisco. We have found that when

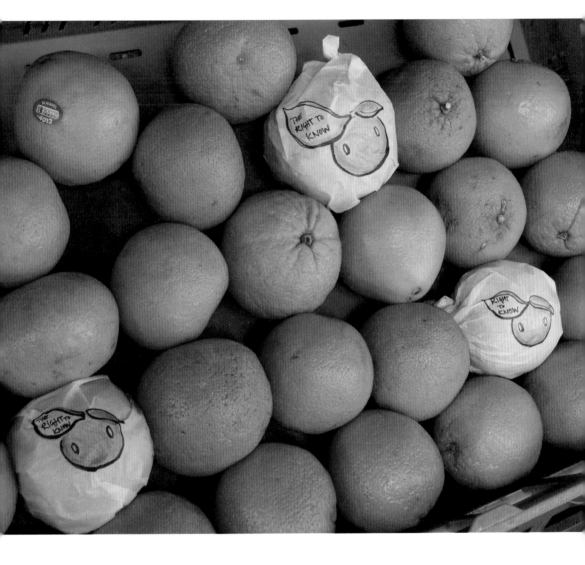

Public test of *F.R.U.I.T.* wrapper
prototype, 2005

three out of the four persons are away from their home and everyday distractions, we can really focus on projects at hand. It also gives a chance for the host to see his or her city with new eyes. Since we met on neutral ground (in Norway), we have tossed the idea around that maybe we should meet like this more often—experiencing a new place together—like a condensed workshop situation. When we are not together, aligning time zones can be tricky, but we all try to work around this and so far it has not been prohibitive.

SS: Do you tend to take responsibility for different parts of a project? Do you take turns with one person as the point person for each project? (I've been in most direct contact with Amy on this project so far, and I'm curious whether that's your preferred mode of working.)

FS: Depending on the origin of the project, different people become the contact. For instance, Nis received a grant from the Danish Art Foundation to bring Free Soil members Stijn, Joni, and Amy to Copenhagen for a week in 2004 to produce the Free Soil website and write proposals for other shows and festivals. In this case Nis was the contact. For *Beyond Green* Amy has been the contact person, mostly due to location and language. Ideally we try to work as a distributed brain, but this is not always the case.

SS: Are there other artists or thinkers who have been particularly influential for you, individually or collectively?

AF: A ceramics teacher, Joe Hawley, in undergraduate studies told me, "Art is a verb!" I have always held this close to my heart. Paolo Soleri and Miguel de Cervantes's Quixote share the same umbrella in terms of perseverance and fantasy. Recently I have been charmed by Tim Hunkin's *Secret Life of Machines* series. Others: Hans Haacke, Jacob Moreno, Rudolph Steiner, Stephen Willats.

NR: People working close to me have always been very important, from a distance a few would be: curator Mary Jane Jacob, artists Group Material, Rirkrit Tiravanija, Öyvind Fahlström, and Bas Jan Ader, and the film *Safe* by Todd Haynes.

MM: *Flatland* by Edwin Abbott keeps reminding me that we can always zoom out into dimensions we didn't imagine possible and can have tremendous fun with that. Shigeru Miyamoto for creating these cunning worlds that people enjoy exploring. My childhood hero Heinz Sielmann, an old German fossil who made animal documentaries. Also the Interaction Design Institute Iyrea: in the last couple of years people decided to move from all over the world to a little town in the north of Italy, carrying along with them all kinds of personal skills and histories, all of them ready to experiment with this amorphous field "Interaction Design" in their own and joint ways.

SS: How do you see your work fitting into the current state of global art practice?

AF/NR: Maybe we can rephrase the question to ask why we choose to work under the umbrella of art rather than activism. We all agree that art remains more open than activism. We have found that much activism is bound by prescribed thoughts, dogma, and manifestoes. Art does not have to have one aim and that helps us avoid clichéd activist positions. This openness possibly allows for more mobility without constraints of "right" and "wrong." We share a common, growing concern about a world that is on the verge of an environmental, military, and economic crisis. We are compelled to engage with this reality.

MM: Recently we have observed that an interest in environmental awareness and sustainability has gained relevance not only in many art projects but also within business

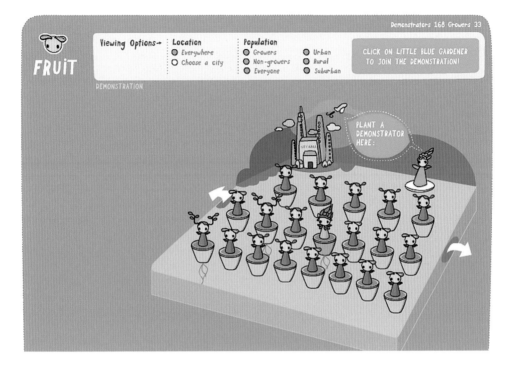

strategies, technology industries, and politics. This development is as exciting as it is curious. At the same time, I feel there is a danger in words like "sustainable" becoming popular buzzwords—they inevitably will lose their meaning as people grow tired of them. Artists' intentions may be doubted when they address such topics. It will be an interesting challenge to keep people on their toes.

SS: As I write, you're finalizing *F.R.U.I.T.*, your project for *Beyond Green*. Please tell me about your current plans for the project.

AF/NR: Embedded in the food we consume are nutrients along with a cornucopia of information: historical and current political, cultural, and environmental data. When you purchase an orange from a local grocer for 50¢, you are purchasing more than what can fit in your hand. Free Soil has been interested in following oranges from shelf back to the farm. In this journey oranges pass through many hands before they reach the shelves. We chose to follow oranges because they are available year-round in all of the three cities where we reside. The physical properties of the orange were also of interest, in that it truly is the most communal fruit—oranges are very easy to share among a group. We aim to unearth information about the distribution of food into urban spaces and its effect on CO_2 emissions, economics, social relations, and the like. For *Beyond Green*, we will build a fruit stand that will serve as an information center. Instead of shopping for the fruit, people can "shop" for the information that is part of the fruit: the "fruit memory." We will produce a set of fruit wrappers printed with information, along with an interactive website.

F.R.U.I.T., 2005 (detail)
Digital graphic from
Free Soil Web site
(CAT. 3)

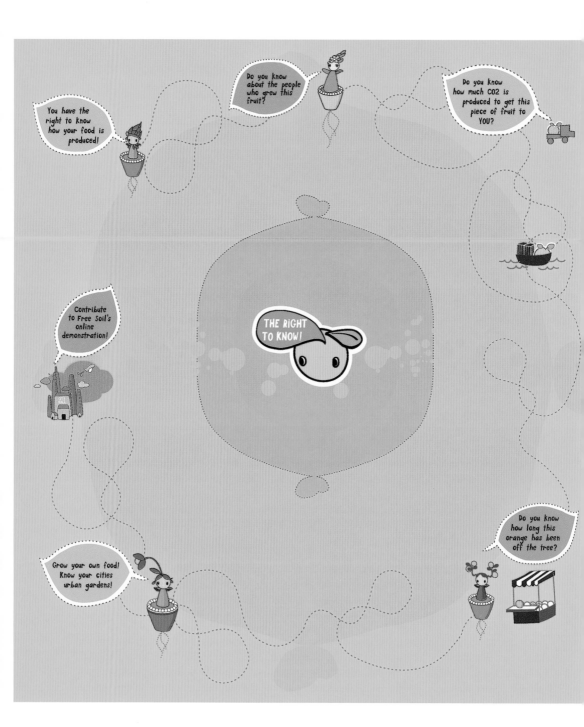

F.R.U.I.T., 2005 (detail)
Digital graphic of
wrapper front (left) and
back (right)
(CAT. 3)

Local Food Movements
1960's San Francisco, California

The Food Conspiracy was political to the core and was used as a way to organize neighborhoods against price-gouging super-markets and to raise consciousness about the irrationality of the profit system. They used food distribution as a way to organize and politically educate the community. It strove to build a "People's Food System," including a network of small, community food stores through-out San Francisco. It originally began for the purpose of allowing groups of people to buy fresh products in bulk, but quickly grew beyond weekly politically charged potlucks into an autonomous network of neighborhood grocery stores. These "buying clubs" morphed into legitimate and successful businesses, but they didn't lose their political edge. If anything, the storefronts helped center the groups' politics by giving them a physical space in which to ground their activities.

Farm to Shelf → CO2 emissions

"Foodmiles" is the distance that food travels from the place it was growing to the place it is purchased by the end consumer. Often these journeys go half way around the world, taking detours and inefficient paths. The energy it takes to carry billions of tons of fruit each year from remote farms to the city is enormous and has a major impact on the environments it passes through. Since the cost for shipment has hardly any effect on the price of products, most people are not concerned about buying locally grown food. However, buying local is not only better for the environment, but also supports the local economy. It is often healthier and provides consumers with fresher and therefore tastier products.

-Food travels on average 1,300 miles from farm to table.
-39% of what Americans eat is produced in other countries.

Urban Farming
Growing food inside the city.

The United Nations recently reported that 50% of the world's population will be living in cities by 2007.

Urban farming is an effective way of cutting down CO2 emissions both in reducing Food Miles and providing open spaces. It makes a greener and healthier city and provides a way for neighborhoods to organize. Farming together produces a sense of community and forges a connection between food production and food consumption that is becoming lost. Some crops have considerable yield potential and can provide up to 50kg of fresh produce per square meter per year in the city.

Demand subsidized urban gardening for individuals and groups!

Edible Parks! Plant fruit trees in public parks!

PLANT NOW!

Free Soil → Right to Know Campaign
www.free-soil.org/fruit

Free soil set out to investigate contemporary food production and its relation to the city. By following oranges from farm to shelf we were offered an insight into the complexity of this operation. Much of the information about what we eat is lost within this complex process, like how much waste is produced or who it is produced by... The corporations who control our food systems hold detailed information about each step of the process down to the tree the fruit comes from, but this information is held tight and proprietary. Let us demand to know more!

We have the Right to Know!

An online DEMONSTRATOR is waiting for you!! Go now, to free-soil.org/fruit to plant a demonstrator. Contribute your voice and join a growing community of people who want to KNOW! Take the survey and your demonstrator will grow!

You have the right to know how your food is produced!

Do you know about the people who grew this fruit?

Do you know how much CO2 is produced to get this orange to YOU?

Do you know how long this orange has been off its tree?

Grow your own food! Know your cities urban gardens!

Contribute now to Free Soil's online demon-stration! →

GO NOW!

www.free-soil.org/fruit

www.free-soil.org
Free Soil is an international collective of artists, activists, researchers and gardeners who take a participatory role in the transformation of our environment.

SS: Could you go into a little more detail on how you plan to present your findings?

FS: Information we have gathered will be presented through a Website and also through the wrappers, which we will give away in the museum. For the opening reception we will have fresh oranges wrapped in Free Soil wrappers as giveaways. These paper wrappers will be printed with information about urban farming and the transport patterns of fruit. *F.R.U.I.T.* wrappers will highlight the benefits of urban gardening: socializing, cutting down on CO_2, putting the growing power in the hands of the people, building skills, sharing gardening secrets, neighborhood organization... many benefits can emerge from within the structure of an urban garden. One project we learned about during the research and that we draw inspiration from is the Food Conspiracy. The Food Conspiracy came out of the Black Panther movement. It was a network of neighborhood food-buying groups in the 1970s, based in the San Francisco Bay area, that bought organic food from rural farms and local distributors. The Conspiracy was large enough to purchase food at wholesale prices and pass the savings on to individual members. Many of the groups were run out of garages and living rooms and quickly grew beyond weekly, politically charged potlucks to an autonomous network of neighborhood grocery stores. An outcropping of the Food Conspiracy was the People's Common Operating Warehouse of San Francisco, a political project using food distribution as a form of community organizing and political education. The People's Warehouse was striving to build a "People's Food System," including a network of small community food stores throughout San Francisco.

SS: How do you see your work, and this project in particular, intersecting with sustainable design?

AF/NR: *F.R.U.I.T.* hopes to reveal things that are often hidden, so we can see how things actually work and then consider alternate ways of living and producing food. Most people are disconnected from the origins of their food, and this removal erases responsibility. On the level of the installation, we will use recyclable material where possible.

MM: Using digital technology is always problematic in terms of sustainability if we consider that producing even a microchip has a considerable environmental impact. At the same time, this technology allows us to reach people in different and often unexpected ways.

SS: How did you become interested in sustainability?

MM: In my childhood I approached environmental matters with the utmost sincerity. Founding the nature research team "Delkakaduphin" (a combination of the German words for cockatoo and dolphin) with my young friend Thomas, I was concerned with things like recording blackbirds singing, only to have them be drowned out by helicopters, which I saw as clear proof of humans invading nature. I think by now I've shifted to a much less activist approach.

AF: I grew up between my mother's organic farm and my father's commercial farm and pesticide company, and these conflicting practices fostered questions about how to maintain quality of life within a world slowly being depleted of resources. I was very influenced by my mother's holistic approach to growing food. My stepfather was a local activist and was very successful in the early 1980s, with the help of Mothers for Peace, at keeping oil platforms from being built along California's Central Coast. Seeing this sort of progress and action within a small community inspired me and built a sense of confidence that things can change.

NR: The Brundtland Report from 1987 was an important influence early on; this report tied sustainability to environmental protection, economic growth, and social equity. For me, making art that engaged in the environment resounded well with critiques of art institutions for not dealing with social and political issues.

SS: What do you see as the biggest challenges to developing and maintaining a sustainable art practice?

AF: I am not sure making "sustainable art" was initially a conscious effort. It has more to do with a way of life or a system of operation. It is important to approach projects from a holistic point of view, such that conceptually and formally the work becomes a sustainable system. Like concept of "sustainable systems" in the universe, the most challenging aspect of "sustainable art" is entropy.

NR: How art enters society and leaves it again is for me central to sustainability. Time transforms contemporary art into historic documents, so it is a question we constantly face, and on the material level I like artworks that can be recycled or at least have an idea of their own timeliness. I like how material questions connect us. If conceptual art held a critique of commodification, it was also in many ways a pure negation and left out bodily and sensual issues. Sustainability can help recover that sense of materiality, by heightening and complicating our awareness of how we live in, relate to, and interact with our surroundings.

SS: Could you talk about your design sensibility? It's sleek in some ways, but there's a real friendliness to the graphic style, and a do-it-yourself aesthetic to the objects and installations.

FS: We have a common interest in user-friendliness and accessibility. The design is not made to build a hierarchy, but to stay at eye level with the viewer or participant. It is a way of communicating. Creating a visual language in our projects is essential. In a way, it is a sort of domestication of the museum.

To quote Renny Pritikin on the damselfish of the Galapagos: "Each damselfish knows every pebble and leaf in its little corner of the tide pool and will remove any object that disturbs the perfection of their orderly homes. It is tempting to speculate whether these tiny beings see themselves as responsible for a little bit of order in a chaotic universe— i.e. are artists—or if they assume that the universe is perfect and they are responsible for keeping their little section consistent with the whole—i.e. are devout."[1]

June 2005

1. Renny Pritkin, "Fellos,"
in *Harvest: Futurefarmers 1995-2002*
(Hong Kong: Systems Ltd., 2002): 104.

JAM

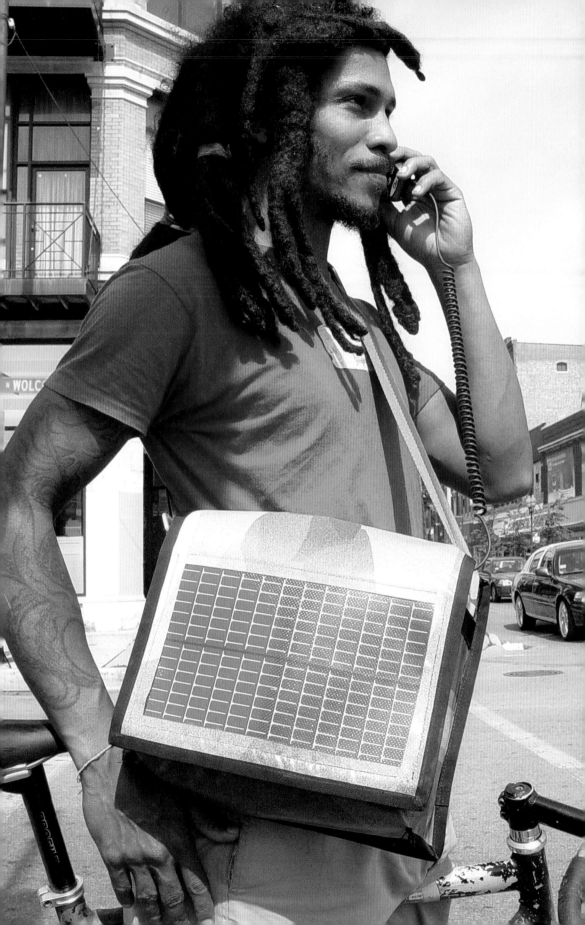

Jane Palmer and Marianne Fairbanks

have been working together as JAM since 2000. JAM creates projects that offer poetic and practical ways of embedding sustainable habits within daily life; this approach extends to Palmer and Fairbanks' work as artists, teachers, and citizens.

JAM has combined its members' training in fiber arts with their interest in sustainable practices in a project that combines art, design, and a socially motivated form of entrepreneurship. They created a series of prototypes for garments and bags equipped with lightweight, flexible solar panels that power small-scale electric devices like cell phones. Through collaborations with technical and business experts, designers, and distributors, JAM plans to move beyond prototyping and to produce them on a larger scale while continuing to use sustainable production strategies such as hiring local labor and making the bags from sturdy and/or repurposed waste materials. As part of this push to get their technology into wider use, JAM is also developing kits that contain the electronics necessary to transform one's own bags and are sharing their plans with designers.

JAM originally called the project *personal power* and then changed the name to *Noon Solar,* a shift that suggests the ways in which JAM's creations can carry multiple identities as they move among different contexts. *personal power* grew out of Palmer and Fairbanks' Iraq-heightened awareness of the political consequences of dependence on oil and other fossil fuels, but the pair decided that in the commercial arena it made sense to downplay a "crunchy" sensibility in favor of a more open-ended and contemporary-sounding name. This fits with the look of the objects. These fashionable bags allow users to step free of the electrical power grid while retaining the ability to hook into communication networks, be stylish, or simply enjoy a little music. The name *Noon Solar* thus provides a bit of camouflage for JAM's utopian aims, and the hip or eco-conscious consumers who will be the bag's first users will participate in a work of social sculpture whether or not they're aware of or interested in JAM's larger project of making personal solar technology desirable, affordable, and widely available.

To that end, JAM will continue to sell limited-edition prototypes of the bags and will show the project in exhibitions. Their new installation, *Jump Off*, presents a convivial grouping of the bags and includes an animation by Arthur Jones that highlights JAM's concerns about the interconnections between energy consumption and military action.

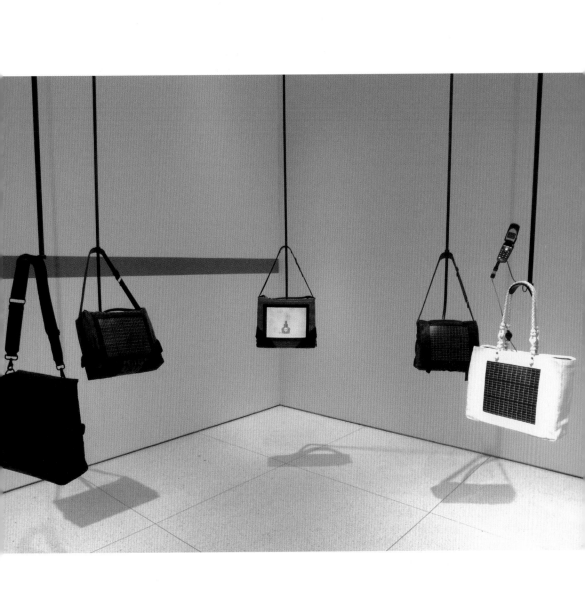

Jump Off, 2005
Mixed media installation with handmade cloth and leather bags,
flexible solar panels, flat screen monitor, DVD player, cell phone,
and electrical circuitry; Flash animation by Arthur Jones
Installation view at Smart Museum of Art, University of Chicago
(CAT. 4)

Noon Solar bag in use, 2004

Statement

We have been working together in Chicago for the past five years. We came together in grad school at a point when we were both looking to get beyond the boundaries of our studios. We wondered how we could make art that would be relevant and interesting beyond the classroom or studio when we were not meaningfully interacting with the realities of our locality, the communities around us, or the issues that were of concern to people beyond the art world. We began investigating ways of creating work that could reach a broader audience and be more accessible than most of the conceptual work we saw being produced. Once we decided to collaborate, it changed our entire approach to making art. We had to let go of the notion of sole authorship, which inspired us to seek out new interactions and gave us confidence to go out and meet people with whom we might join forces. Working together was essential in spurring us to start asking others for their help and to pursue more ambitious projects than we could achieve alone.

We've become more interested in cultivating interactive, participatory, and educational experiences. We search for ways to initiate and show work in new contexts and environments, places where the work might not necessarily be seen as "Art" but where the audience for the work far exceeds the number of people that might see a piece hanging in a gallery. As Suzanne Lacy writes in *Mapping the Terrain*, "these expansive venues allow not only for a broader reach but ultimately a more integrated role for the artist in society."[1]

■ ■ ■

Many of our projects have explored the notion of people-powered energy, which has led us over the past few years to the *Noon Solar* project. We started working on this project, initially titled *Personal Power*, around the time of the run-up to the current Iraq war. Feeling powerless in our country's decision-making process, we started talking about ways to bring power back to the individual. Because the war felt so driven by our country's greed for oil, we wondered if there was a way to use solar power on a scale that could enable each one of us to be independent from the electrical power grid.

After some initial investigation, we found a company that made flexible and lightweight solar panels. We realized that we could integrate these into garments and handbags to create mobile power units for handheld electronic devices such as cell phones. Our goal was to find a way to disconnect from conventional power sources and to still be connected to a larger network of information. With the help of local solar expert Vladimir Nekola, we created a few prototypes of different potential applications. It was our hope that by integrating solar power into items that people already used—like a handbag or backpack—they might become more interested in using solar power on a larger scale.

Realizing that this project could be useful in many areas of the world—particularly in countries where many communities not yet wired for electricity have access to cell phones—we decided to make it into a product, not just a conceptual project. We chose this route because we know that as a single piece of art or as a prototype it will have little or no effect on changing the current dependency on foreign and nonrenewable energy sources, whereas it might have some more measurable effect as a more widely available consumer product. For the past year and a half, we have been working

1. Suzanne Lacy, *Mapping the Terrain: New Genre Public Art* (Seattle: Washington Bay Press, 1994): 40.

with business students, engineers, and pattern designers to try to make this a reality. One thing that sets us apart as a business is that we came up with this idea in order to distribute new power sources, not to make money. Admittedly, this is an odd way to approach a business in a money-driven society, but we look forward to committing our ethics and values of sustainable growth into our business.

．．．

In our own practice, we have adopted various values and concepts from decades of artists working within frameworks of public art, environmental art, community based art, feminist art, and activist art. This includes thinking about materials and where they come from; whom the work is for; how to be socially responsible; the distribution of materials and information; how to provide solutions; and how to expand our audience. These ideals have also informed our approach to teaching.

We created a class for the School of the Art Institute of Chicago called "Sustainable Forms." As teachers, we feel it is important to show students alternative options to the more traditional art structures of galleries and museums. We can encourage students to make their work accessible to a broad audience by being socially and locally relevant, politically engaged, and generous. We also promote the benefit of creating partnerships and exploring venues outside the traditional art system. We hope that these considerations can show students ways to sustain productive, meaningful practices over time. This independence provides freedom to think creatively and critically about their role as artists. We need to acknowledge that each year thousands of students are being trained as visual artists to eventually enter into a system that does not provide concrete jobs for them.

Perhaps one day, jobs for artists will be abundant if their roles are expanded and integrated into a new social structure that places a higher value on their creative work. William McDonough and Michael Braungart describe the ideal sustainable society in their book *Cradle to Cradle* (2002). They write that "every creature is involved in maintaining the entire system; all of them work in creative and ultimately effective ways for the success of the whole."[2] This is the healthy social structure we strive for in our life, art practice, and pedagogy.

February 2005

JAM thanks Anthony Burton, Byron Crawford, Waverly Deutch, Janet Ecklebarger, Gideo Gradman, Eliot Irwin, Kiyomi Kimble, Jim Olejniczak, Brian Palacios, Jim and Jane Palmer, Robin Richman, and Griffin Rodriguez.

2. William McDonough and Michael Braungart, *Cradle to Cradle* (New York: North Point Press, 2002): 122.

Jump Off, 2005 (detail) Still from Flash animation by Arthur Jones (CAT. 4)

LEARNING GROUP

Opposite: *Collected Material Dwelling, Model 1:1*, 2005 (detail)
Installation view at Smart Museum of Art, University of Chicago
(CAT. 5)

Learning Group members

Brett Bloom, Julio Castro, Rikke Luther, and Cecilia Wendt have been working together since 2004. Through their collaborative art projects, they develop strategies for putting common materials to creative new uses that address problems within the built environment. These projects model inexpensive, concrete, and sometimes playful ways that people anywhere can employ renewable or waste materials to improve the quality of their lives. They devise methods to gather and use these materials, making drawings, models, posters, and sculptural structures to test their ideas and share their processes and designs with others. Each member has gained recognition for prior work with other artists' groups. Bloom is one of the founders of the American artists' group Temporary Services; Castro is cofounder of the Mexican group Tercerunquinto; and Luther and Wendt are cofounders of the Scandinavian group N55.

During a residency in Japan in 2004, Learning Group developed a process, which they call a *Collecting System*, to gather waste paper and cardboard. They collaborated with students and community members to turn this material into several projects, including a 1:1 scale model of a domed cardboard dwelling called *Learning by Sea Urchin*, which has since been recycled. The project is represented in the exhibition through a *Learning Poster* and drawings.

In 2005, the group set up another *Collecting System* in squatted lands on the outskirts of Monterrey, Mexico. In collaboration with residents, and in response to the specific needs and resources of the site, Learning Group developed a system to turn discarded plastic bottles into building material. For this exhibition, they produced a 1:1 scale model made from cardboard and plastic bottles collected from the University of Chicago's waste stream and other Chicago sources. The structure can be broken down into small components for easy assembly as the exhibition travels. A *Learning Poster* and several drawings show other parts of the process.

Learning Group has also proposed a project for growing mushrooms in cavelike spaces tunneled beneath houses. Given legal restrictions, such a project would have to be underground in both the literal and figurative senses: a subterranean network of urban agriculture. The unrealized project embodies Learning Group's ideas about self-sufficiency and its belief in the need to make creative, productive use of overlooked spaces and resources. The proposal is part of their series of *Connecting Systems* and is represented in the exhibition by a small model, a *Learning Poster,* and drawings.

Collected Material Dwelling, Model 1:1, 2005
Mixed media installation including recycled cardboard, recycled
bottles, fabric, rope, metal, plastic container, and hose
Installation view at Smart Museum of Art, University of Chicago
(CAT. 5)

Interview

Stephanie Smith: You've only been working as Learning Group for a year. Why did you decide to work together, and what do you each bring to the group?

Rikke Luther: We each come from very different places, giving us different methods and possibilities to work so we can use our own backgrounds in new ways. We all have different histories and different languages. This is what we now are expanding through sharing and mixing.

Brett Bloom: Cecilia and Rikke were cofounders of the Copenhagen-based group N55, which I worked with on several occasions. When they were no longer with N55, Rikke wanted to continue working in a group so she contacted Cecilia, Julio, and me and started discussions with us separately. These discussions eventually led to the production of texts, ideas, and work together, as well as a process that continues to develop.

Cecilia Wendt: It started out of a long-term interest in how education becomes part of persons' lives and produces knowledge and language.

SS: As Brett notes, you all have worked (and some of you continue to work) with other artists' groups apart from Learning Group. What do you each find most interesting or satisfying about working collectively? How do you manage group process across distance?

BB: I am currently active with five groups, some more than others. I am constantly challenged by this way of working—a challenge that doesn't come when I sit by myself in a studio making objects. Each group offers a different social ecosystem, personalities, capabilities, and challenges. Some groups work better than others and have all of their energy aligned. Others require a lot more effort to get them to work. Out of all of these groups, only one approaches "collectivity." The rest are nowhere near that and require other descriptors. The group process is quite scattered and not very efficient yet with Learning Group, but it is still young and we are still discovering how to work with each other. We all live in different countries and this creates both a very interesting way of working and some obvious difficulties in keeping communication steady.

CW: There are so many different ways of collaborating. In this case the four of us have gathered around certain issues and situations and worked in relationship to those, but each of one of us works in another way. The problem that we are scattered will become part of the discussion, I hope.

Julio Castro: It is about the creation of strategies and how those are essential in all group work. In this case you have a net of people in different contexts interested in finding common issues to work on and then seeing how they function in each particular context. Some of the ideas and strategies may or may not be related to other issues that are useful to the group where I'm primarily working and at the same time are in this net. You can also work on more aspects of the ideas when others are involved. Our ideas are in an open structure and not as conditioned as they would be if they were the work of a group that had to sustain a style.

I remember the time when we talked about Escuela (or "school", which was a formative concept for our working together). A discussion point that was very shocking for me was that if one of our projects was constructed in Mexico, it would be related to fighting against poverty, but if the same thing were done in Europe, then it would be related to making resistance. I guess this is a main issue for me: doing work in relation to a context,

seeing how the work is absorbed and modified by the context, and considering how this interpretation could be radically modified when the context changes.

SS: I'm glad you've decided on a name for the group—I know it's something you've been thinking about for a while now. How did you come to the name Learning Group? I like its focus on process and the suggestion that not only is your work meant to be instructive for others but also that it allows you to continue to stretch and to learn, yourselves.

JC: I guess this is part of the job for Learning Group, or for any group or individual. I relate the name more to a sense of commitment and involvement, where one can decide how deeply to get into a project, to bring part of one's knowledge and make it a component of a project.

CW: The collaboration in this case is not an end or form in itself. It has been an attempt to discuss learning as well. This started out with a kind of basic distribution system in order to talk about the activity in our projects in Japan and Mexico: the *Learning Poster*. We also use a Website where we gather material and thinking; it is called *Learning Site*, a notion we use for other situations as well.

SS: Are there specific aspects of your prior work that have informed this new endeavor? For instance, Rikke and Cecilia, the sustainable ethos and do-it-yourself sensibility of these new projects resonates with your former work with N55, but in terms of design the aesthetic is much warmer, friendlier.

RL: In relation to do-it-yourself it could be called "do-it-ourselves"—the work includes a direct dialogue with other persons in a more specific situation and at the *Learning Site*. The aesthetics are related to the specific situations we encounter.

CW: The work we did with N55 was part of a situation just as this is part of a situation. From that perspective our attitude or interests have not changed, just our conditions.

BB: The sensibilities of Learning Group are informed by all our prior work and the special situation that is created by our working together. It will necessarily be different from N55, Temporary Services, or Tercercinquento. We really want our explorations to be both visually engaging and also have a real, even if tiny, impact on the local contexts within which they work. There is so little concern with how this work circulates in an art context. We all have played that game and don't need to repeat it with this work. There is a great freedom in this aspect for me.

JC: In my case, after making a project in the outskirts of Monterrey (a city in northern Mexico) and seeing how people can be a part of the process and also its receivers, it was important to see how more symbolic the shape could be and how relevant it was to explore other dynamics outside of the institutional way of doing things. One can simultaneously rethink authorship, leading a project, and the directions in which one can speculate about how a work can be when released from the expectations conditioned by the institutionalism of the art world. It is really relevant to see how the ideas and preconceptions disappear when you let the work go on its own and let the context be a part of the process. You can then say that the work is "alive." You can recover elements and bring them into the institution but must always think about the ethics of what you are connected to in the different worlds.

I really liked to see how Monterrey was expanding and how much of the expansion in this context created new strategies to manage its realities, for instance: the use of waste of others; the recovering of objects, clothes, materials for construction, which provides an economy linked to the city; copying standard methods of construction; use of space;

Following pages:
Learning Poster #001 > Collecting Systems, 2005
Inkjet print
(CAT. 8)

Flyers were distributed in the city of Moriya, Japan, informing about [Collecting System]; the collection of paper materials from home and work places. The donated paper was either delivered to the school or it was picked up.

[Places producing Unused Material > Collecting System]: Paper was collected from to December in the city of Moriya, Japan.

[Cooking Glue]: The rice has to be boiled in plenty of water for a whole day. The rice is poured through a sieve. Boro salts are added to the paper to prevent decay, mold, and pests.

[Paper Brick]: Constructed of rice glue and collected shredded paper.

Block sizes for [Paper Dwelling > Learning by Sea Urchin, Model 1:1]. The cardboard is cut and glued together.

The dwelling is being used in the education place AIT, Tokyo. After, it will be mo bridge or other shelter as a way to integrate with the already existing construction becoming a part of the build environment.

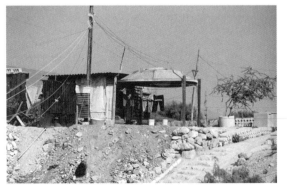

A dwelling constructed out of unused materials, Monterrey, Mexico.
A satellite dish is used as a small roof.

A new neighborhood with a kindergarten and public school which are shared with area. The city will reach the land sooner or later. The conditions are that the squat to adopt the urban model or leave the area to further terrains.

ucing Unused Material > Collecting System]: The unused materials were used for
[Paper Dwelling > Learning by Sea Urchin, Model 1:1], and working with [Cooking
aper Brick].

[Places producing Unused Material > Collecting System]: Collecting site.

] was built from materials from [Collecting System] in cooperation with 78 persons
Elementary School, Moriya, Japan.

[Walking City]: After a few days of constructing wearable buildings, the city walked out of the
school.

ling > Learning by Sea Urchin, Model 1:1] is constructed out of cardboard gathered
ting System]. The structure is copying the shell of a Sea Urchin.

After being at AIT the dwelling was taken apart and recycled in the official state system.

ystem]:

system] gathers unused materials to be used in local daily life.

erials accumulated by [Collecting System] are to be used for education, research
ings.

Collecting System] in practice:

used materials produced by households are state property and controlled by the
er, in many municipalities, the collecting system of unused materials is privatized,
information of the collecting system is still produced and managed by the munici-
llel to this, pirate companies are collecting unused materials. This means that it is
nybody to get access to the production of unused materials.

st of the unused materials are named as "Valued Garbage". Much of the unused
e being shipped to areas where it is inexpensive to have it transformed and sold as
s, containers, and etcetera.

The [Collecting System] was set up in Moriya, Japan, in 2004. It collected shredded paper and
cardboard for experiments with producing [Paper Brick], for constructing insulated dwellings
[Paper Dwelling > Learning by Sea Urchin, Model 1:1], and making [Walking City].

[Collecting System] is going to be established in a periphery zone of the city of Monterrey,
Mexico, in 2005. In this area there are about 300 families living on squatted land. The econo-
my of the place is constituted by self employment and from collecting unused materials from
which they obtain construction materials that later on are used for building temporary
dwellings. A way to have more sustainable housing is to merge into the already existing and
expanding urban planning of the city. This is done by using the same architectural traits as legal
dwellings. Concrete is used as a main material, which is an important local industry.

[Collecting System] will copy the economy and methods that are carried out in the area in order
to research materials for building systems and dwellings.

Learning Poster #001, 2005. By Julio Castro, Cecilia Wendt, Rikke Luther ,and Brett Bloom

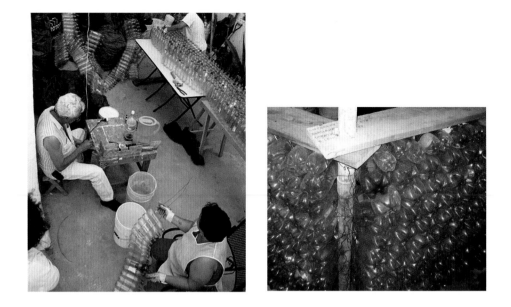

urbanism; etc. This happens more in a symbolic way than the one we usually know.

SS: Could you explain the basic principles of *Collecting System*? This has been the main focus of your work thus far, and your central project for *Beyond Green* comes out of it.

BB: We pay close attention to multiple aspects of a local situation. We ask several questions. Are there material and human resources that are leftover or unused? Who has access and control of these materials? What conditions are people living in? What can our abilities and concerns do to make something useful occur in this situation? We then identify those aspects that concern us the most and try to implement a useful project that includes, among other things, learning about waste, energy use, employment, local social and economic ecologies, self-empowerment, and so on. We make posters, models, and other supporting material that helps us learn and also spreads the knowledge we accumulate.

RL: *Collecting System* is constructed out of some of the possibilities of a given situation and points out some of the social and economic structures that dominate the space. We use leftovers, in relation to thinking and discussion about how to merge our work into already existing and expanding urban planning and economies. From the perspective of sustainability it is often not an optimal solution (if you can even talk about optimal situations in this case).

SS: *Collecting System* has so far been put into practice in several locations. Could you talk about how it's been implemented in Japan and Mexico?

RL: In Japan, unused materials produced by households are state property or private property but managed by the municipalities. In addition, pirate companies are collecting them. As a consequence it is difficult to get access to unused materials. We set up another collecting system for getting material for the experiments, and flyers were distributed that informed about the work that the materials gathered through *Collecting System* would be a part of. We got appointments with different offices and shops, and we collected the unused material by car or by bike; some persons delivered it to the school.

Community members working to assemble a bottle dwelling
in Monterrey, Mexico (left), a detail of the construction (center),
and the completed structure (opposite), 2005

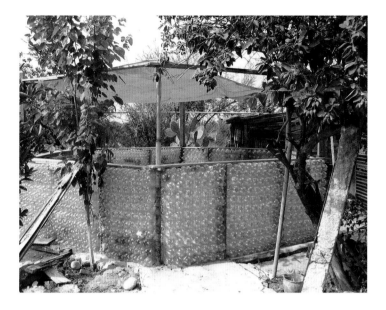

The gathered unused material was used for different purposes. Shredded paper was used for experiments with paper bricks for dwellings. The paper was used for papier mâché models. *Paper Dwelling > Learning by Sea Urchin, Model 1:1* was made out of cardboard and after a period at the Arts Initiative Tokyo, where it was used, it went into the Japanese recycling system. *Walking City* was an activity with 78 persons at the Goshu Elementary School. After a few days of constructing more than 50 wearable buildings out of the cardboard, the city walked out of the school.

JC: The dynamic in Mexico was about creating a workshop while the collection system was working simultaneously. The neighborhood was involved in the collection of material and was shown part of the final results of the construction and how this waste can be transformed into another type of object with its own values as a construction and as a dwelling. After that a small group of people previously working in the workshop helped to construct a room 6 x 3 meters wide. As a result of the initial construction, people asked that a few more be made. The original group split into a few to spread the knowledge of how to make the dwelling.

SS: For *Beyond Green*, you will make a model of the cardboard-and-bottle building method that you've just tested in Mexico; here it will be built using material collected on campus. Since you've already tested the system in Mexico, do you see the model functioning here as a learning tool for others—a way of modeling/spreading your ideas—or do you still have things you want to learn by making a new, portable version of the structure?

JC: Both can work because the method could be improved every time that a construction is made. The help of others and uses of different technologies could change the construction design and process a lot. It depends on many circumstances.

BB: We use scale models and 1:1 models precisely as you suggest: as learning tools. These are both for us and for others. Models are wonderful because they allow you to mentally place yourself inside the worlds they suggest. We can't take everyone with us to Mexico, but being in the same room with the 1:1 model will get you a lot closer and

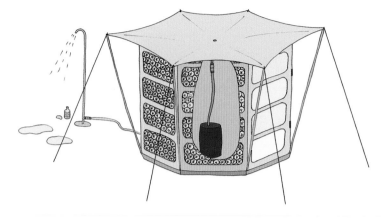

show you how you could build something similar with your own waste. They are also placeholders of sorts. That's also true of the papier mâché scale model for mushroom farming that's included in the show. We will eventually build underground mushroom farms here in Chicago, but this will take several years to realize. There is so much to consider and actually doing it is highly illegal. The models make the ideas concrete and present.

SS: Could you talk more generally about the role of the drawings in your practice? They have such a particular and very charming style and color sensibility. They also serve many purposes: drawings can create an idealized space for play and open speculation; they're a great way to circulate ideas and plans among the group as you're developing ideas together; and they communicate your sensibility and ideas to others.

JC: Yep, they are charming. Drawings can be very powerful when they are shown as a guide. The drawings, like the learning posters, go beyond that place where they are the basic idea of a project to become a sketch of something that can become real.

RL: Drawings are very much like models, using a language that does not necessarily have to take into account things like bureaucratic conditions. Groups like Superstudio and Archigram did impressive work together through collages; models and drawings have been interesting to look at from the perspective of functionality.

SS: Your projects thus far have focused on problems of sustainability within the built environment. You've devised relatively simple techniques that can be used to build using easily available materials and relatively simple techniques. How did you decide on this focus? And are there particular examples of sustainable design, or ad-hoc or extreme architecture, that have inspired you?

RL: One problem is that having somewhere to live is not considered a basic right. It's a huge ongoing battle. In that perspective we have not been interested in sustainable design as much as we have been interested in looking at what getting a dwelling does for one's life. There are many different things that control these parameters around the world: either you live in shadow cities, on squatted land, or on private property. In Copenhagen, it's impossible to get a place without a lot of capital investment, and if you didn't invest in a house before the real estate market started to boom, getting a home is now very difficult to manage. It's one of the most expensive places to live in Europe. Many people have to live illegally in order to simply to get a place to live. The floating dwelling we did in N55 was built because there was a gray zone in 2000 about rules surrounding building on water. This is not possible anymore due to speculation or other interests. This means that the floating dwelling will be transformed into culture or

Above and opposite: *Collecting and Connecting Systems Drawings* (details), 2005
Six inkjet prints
(CAT. 6)

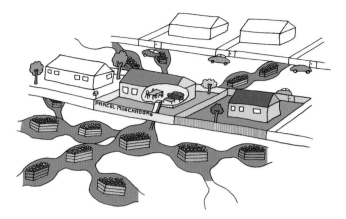

business, so it can get a place in the harbor of Copenhagen, or it will be dismantled and either moved to a new place in a container or just stay in a container.

BB: Everything humans touch, they destroy; there are way too many of us. We have collectively fucked this planet for millennia to come with all kinds of ecological destruction. Our oceans are filled with microscopic pieces of plastic. We have polluted near space—where satellites live—with junk. Our food is contaminated with GMOs and pesticides—the industrialization of our food supply has actually diminished our food's nutritional value and taste in demonstrable ways. We are crowding into bigger and bigger cities that become more desperately unliveable. The best thing would be if people were kicked off the planet. Even our own Greek-Judeo-Christian-Humanist worldview prohibits us from talking frankly about what it would really take to stop the destruction, reduce the number of people on the planet, and design in a completely different way. We can't do that now, so we have to figure out how to work with the horrendous mess we have. Everyone should be working on these issues, not just us and a few like-minded individuals. We can't really talk about sustainability. It just isn't possible until massive change takes place. Right now it is about survival with the least amount of destructive implications. There is nothing sustainable about being human or making things at the moment. You can't be one person and be sustainable even if you live the most "green" life possible. It has to be everyone together. There are people who are thinking in more advanced ways than others, but that is about as good as it gets. The book *Cradle to Cradle* gives us a glimpse of a possible future, but even when we work in these ways, we are still greatly hampered by the billions of people who are living utterly destructive lives.[1]

CW: *Collecting System* takes part in the behavior of the built and changing environment. Unused materials are part of environments and are transforming them by shaping behavior, producing infrastructure, using energy for transformation into new materials, etc. We use plastic bottles and cardboard in the *Collecting Systems* in Mexico and in *Beyond Green*, but the recyclable plastic PET (Polyethylene Terephthalate) is a relatively new material (introduced in 1978) compared to corrugated cardboard. In that sense, in some of our work so far, we try to merge into the already existing built environment by using already existing materials that are already circulating. We get the materials after they've served their first purpose as bottles used to transport liquid or cardboard boxes that have been used to contain other materials. We use them once they are defined as unused materials.

June 2005

1. William McDonough and Michael Braungart, *Cradle to Cradle* (New York: North Point Press, 2002).

Learning Group thanks Kazuya Nakamura and Maho Kakuta for technical drawings and calculations for *Collected Material Dwelling, Model 1:1*.

BRENNAN McGAFFEY

in collaboration with

TEMPORARY SERVICES

Opposite: *Audio Relay*, 2002–ongoing
(2005 manifestation, detail)
(CAT. 11)

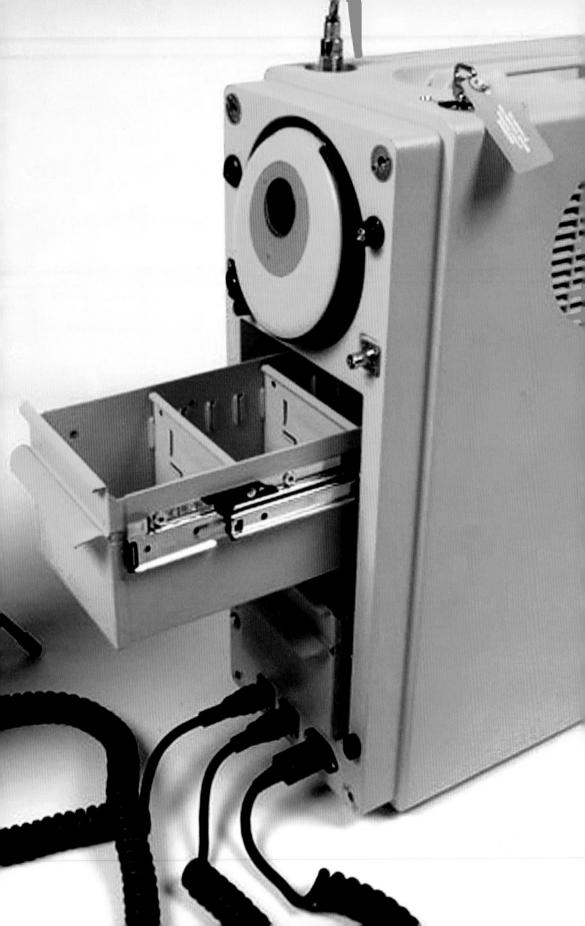

Brennan McGaffey and the

artists' group Temporary Services collaborated on this project but have distinct practices. McGaffey has been developing a series of projects—the *Intermod Series*—for the past five years. These beautifully crafted objects allow the individuals who use them to temporarily disrupt much larger systems such as the electrical power grid and radio waves. Temporary Services has been working together since 1998. Their work is emphatically social: through short-term projects they seek to create dialogue and to emphasize the relationship between aesthetics and ethics. One key initiative, their ongoing *Mobility* series, involves portable archives and other materials that can be transported efficiently and used by Temporary Services or others as the raw materials for social events.

McGaffey designed and built the first version of the *Audio Relay* in 2002 in response to Temporary Services's request for a device to store and broadcast an archive of audio works. It can broadcast them either locally—like a standard stereo—or over the airwaves as an unofficial radio broadcast. (Posters alert people within its small transmission radius of upcoming broadcasts.) McGaffey designed the piece for easy portability, and it can be powered in remote sites by solar panels and a standard car battery. Temporary Services curated the initial audio exhibition for the *Audio Relay*, which they broadcast in Chicago in 2002, but as the piece has traveled to cities from Baltimore to Leipzig others have taken over the curatorial duties: those who host the project are invited to add new audio works and curate their own broadcasts. A new audio archive will be created during the *Beyond Green* exhibition tour as exhibition venues add audio works to the *Audio Relay*.

Both in form and function, the *Audio Relay* embodies a nomadic, self-sustaining approach to producing and disseminating art: although it can be adapted for use in museum spaces and exhibitions like *Beyond Green*, it does not require such standard channels of art-world circulation. When it broadcasts the archive, the work allows individuals to enact change within large systems and also serves as a focal point for actual gatherings and virtual connections among people. And as a portable archive of works of art, the *Audio Relay* takes the private-museum-in-a-box premise of Marcel Duchamp's *boîte-en-valise* (1934–41) and makes it generous by including not only an ever-growing group of artists who contribute material to the archive, but also a changing community of listeners.

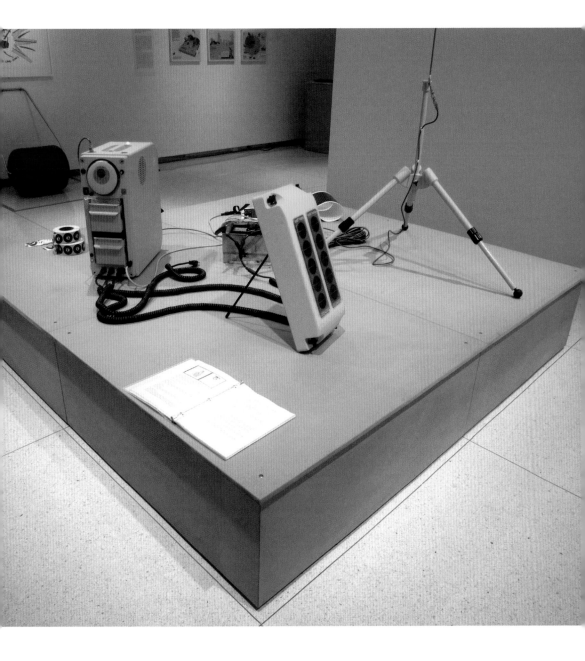

Audio Relay, 2002–ongoing (2005 manifestation)
Painted wood case, audio transmitter, antenna, solar panels,
electric cables, CD player, CDs, speakers, and stickers
Installation view at Smart Museum of Art, University of Chicago
(CAT. 11)

Interview

Stephanie Smith: We'll start the interview just with you, Brennan. Your collaborators, the artists' group Temporary Services, will add their comments at the end of our conversation. Could you start by explaining how the *Audio Relay* (AR) came into being, what it is, and how Temporary Services was (and is) involved in the project?

Brennan McGaffey: In 2002, Brett [Bloom, of Temporary Services] approached me about designing a portable audio unit. The idea was that it could travel and accumulate a library of unusual audio CDs. But it wouldn't just collect the CDs, it would also be able to play them and act as a small exhibit. I added a radio transmitter so that entire neighborhoods can become engaged. I'm responsible for the design and construction plus maintenance. The AR was made for Temporary Services and is part of their ongoing project on mobile structures. They also put together the Chicago version of the audio archive.

SS: The AR is one of a group of works that you call the *Intermod Series*. The series includes a number of objects that you have designed and engineered to cause subtle, temporary disruptions to public space and to invisible networks and systems like power grids and radio waves. Could you say more about the series, and how the AR relates to those other works?

BM: *The Intermod Series* is a group of projects I've created that generate some form of interference, which up to this point has been mostly electromagnetic interference in which I use radio, power lines, stuff like this. But some have involved atmospheric interference and I'll probably come up with others in the future. I consider the AR to be part of this series.

SS: Could you describe one of the *Intermod* projects?

BM: My last project was titled *Utility-Intertied Signal Generation and Transfer* (USG&T) (2003). The USG&T is a special portable electronic unit that I designed to plug into the electrical grid and automatically pattern a pulse-wave signal, distributing it using the network's alternating current. The device transmitted a special type of signal— an Extremely Low Frequency signal—by using and altering the electromagnetic field surrounding the power network in localized areas of Chicago. The signal was inaudible and relied on a passive bioreception. (Additional information about any of these projects is available at the *Intermod Series* Website, including any updates.)

SS: You've said that the *Intermod* projects "generate interference." This occurs in a literal way when you temporarily disrupt the electrical grid or radio frequencies. Could you also talk about interference as a strategy for your art practice?

BM: It creates something phenomena-like. If you put one of the *Intermod* projects in a place where someone is expecting something unusual then its effectiveness is neutralized. Putting art out where it isn't expected is far more interesting. So the project starts as form of interference, but I hope it's more than simply a disruption.

SS: Your projects usually disrupt systems in far-reaching but invisible ways. We can't see the radio waves, but we can see and touch the objects that cause that disruption, as well as the logos and other materials that you design to accompany each *Intermod* piece. They're very carefully designed; the *Intermod* Series has a consistent visual aesthetic. What's the relationship between function and form in the *Intermod* Series?

BM: Hmmm. Design of the objects and graphics would be what you mean by form, right? It's all important. I immerse myself in design strategies that seem relevant for each project. For the AR I was looking at portable radio units, especially military designs. But I never take that too far. Familiarity is one thing, copying outright another.

SS: Were there other sources of inspiration for the objects? For the AR, for instance, were you drawing on sources apart from military technology? I'm thinking of things like sleek, super-lightweight camping gear.

BM: The antenna for the AR collapses or folds for storage. An elastic shock-cord runs through the center of the tubing and binds the antenna sections together. It stretches when you fold it. Anyone reading this who is a backpacker will immediately recognize this design as originating in lightweight tent pole construction. The materials are different, as antennas need to be conductive, but the use of the cord addressed perfectly the problem of keeping the pieces of the antenna together.

SS: Camping and military gear are mass-produced objects. The *Intermod* objects (thus far at any rate) are all laboriously handmade and have an impeccably finished look. Is that important to your con- cept for the work?

BM: That it's handmade? No, not really, but most originals for mold making, even in industry, are still handmade. It would be fine with me if I could send something out to be produced somewhere else, but it's simply not possible for financial reasons. My projects are mostly out-of-pocket. If money ever becomes available for it, I think the AR should be plastic mold-injected. Right now, it's not as durable as it could be.

SS: I'm also interested in your use of marketing strategies for these underground, even illicit projects. For instance you have a "brand" logo for the whole *Intermod Series*, and each individual project has its own slightly retro-feeling logo that you've transformed into stamps, stickers, and at least one poster. Sometimes you've incorporated these materials into mailers that you send out anonymously; they're like small multiples but also spread the word about the projects to those who can't experience the piece in action.

BM: I'm not really marketing my projects, of course. But, yeah, the insidious public

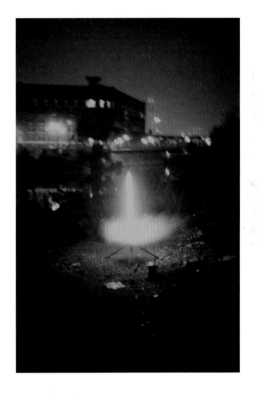

Above: Logo for McGaffey's *Intermod Series* project
Low Altitude Atmospheric Modifications, 2001
Digital graphic

Below: implementation of *Low Altitude Atmospheric Modifications*, Chicago, 2001

relations industry has proven itself to be extremely effective at mass opinion shaping. The history of its development is enlightening along with its connection to psychiatry, intelligence agencies, and so on. Clandestine versions of marketing and control are also very instructive. Borrowing from all these strategies can create a pleasant confusion. Designing logos is just part of this, along with the packaging and presentation. Functionally, logos also help identify the projects and give them focus since they are sent out anonymously.

SS: But that's not the case with the AR, is it? That project isn't anonymous at all.

BM: When these projects are ready to be sent out it just won't work if the first thing you see is my name in capitals, right? It's less important with the AR, but still, I wouldn't feel good about putting my name on the unit itself. With the other projects, it's very important that they blend in, at least initially.

SS: Do you think about your work as an activist or oppositional practice?

BM: Well, I don't know, I guess if you make an effort to be even mildly informed, how can you not end up in a state of opposition? Activism is important, especially now that the mainstream media is so thoroughly controlled. But I think I'm doing something else. I'm not sure what category it comfortably fits in.

SS: How do you see your work in relation to other art (past or current)?

BM: Well, there are certainly examples that could apply, but I think less and less about this. Or I just care less and less. It's not important to me that these projects fit into an art context. I find that what most interests me is outside of it, or acts as an alternative. The Yes Men come to mind. What they do is extraordinary. Locally, Lucky Pierre [an experimental performance group] has put together some very interesting stuff. And working with groups like Temporary Services can be very satisfying.

SS: How do you see the AR fitting into, or pushing against, sustainable design practices?

BM: I think some good stuff is happening in housing design. If you look honestly at our society, however, very little is sustainable in the long term. Sorry to bust out the doom, but it's just the way it is. So design that incorporates sustainable energy consumption is ahead of the curve. Everyone will have to square up to some hard realities eventually and probably sooner rather than later. The design for the AR is, for me, more about portability. Using a car battery allows you to put it anywhere you want, outdoors, on a roof, wherever. And you can recharge the battery using the solar panels. But you can also run it off of any regular AC electrical outlet. So I guess it's both a sustainable and nonsustainable design.

SS: We'll shift now to Temporary Services members Brett Bloom and Marc Fischer. After Brennan produced the *Audio Relay*, Temporary Services took over the role of coordinating its use in an ongoing series of presentations and short-term broadcasts, starting in Chicago and then going on to other cities. Could you talk about the parameters that you establish for the use of the AR and for the kinds of audio works that are included in the ever-growing audio archive that it houses and broadcasts as it travels?

Brett Bloom: Independent music, experimental audio, field recordings, radio plays, interviews—these are all welcome additions to the audio archive. We really like to see projects that push the AR so that it is not just transmitting, but maybe creating, as Brennan has said, some sort of phenomenon or phenomenological investigation. Radio waves are things in the world just like colored mud or precious metals and really are a lot more open for experimentation than the commerce-induced blandness of most radio.

We really hope to get material that is unique, not commercially available, and challenges our ideas of what can go in the AR. This has only happened on a couple of occasions. Usually we get material that isn't all that interesting. We try to set parameters for what gets included. When we do the programming ourselves and contact people to contribute, the quality has been high. But when we turn it over to others to solicit contributions, well, it hasn't been so satisfying. This is an ongoing process and experiment. With mainstream media (and I lump college radio in with this) there is a really closed down idea of how radio can function in the world. The AR should function in a way that doesn't reproduce the passive, consumptive model that dominates almost all radio at the moment.

SS: There are now going to be two versions of the AR in the world—the original one and the new version that Brennan is producing for *Beyond Green*. Could there be more? Should there be more?

Marc Fischer: More is more. It would be great to have an inject-o-mold made so that additional *Audio Relays* could be fabricated more easily. Brennan continually finds ways of enhancing the AR, and who are we to stop him? We hope that one day there is the budget to produce many more copies of the AR that can be spread out to a greater number of places and used in ways we can't even imagine. Time and money, as usual, hold us back. Archiving and logging the ever-growing number of CDs that people donate to the AR archives is also a challenge.

Left: *Utility Intertied Signal Generation and Transfer*, 2003
Cast plastic case and electronics

Right: Mailer and stickers for *Utility Intertied Signal Generation and Transfer*, 2003
Printed matter

BB: We have also talked about more clandestine, boosted ARs that could "squat" the entire radio dial. We are nowhere near seeing something like this realized. We even talked about an AR that could interface more readily with the Internet, but again, this is only talk.

SS: Will the new AR have its own separate audio archive that's distinct to the history of this object's use, or will you try to keep the two archives synchronized?

MF: The two ARs can have different audio archives.

SS: What's your best-case scenario for displaying it within a museum or gallery show? In an ideal situation, would it be broadcasting all the time, for instance? Do you think the piece is compromised at all for those who will only see it when it's inert?

MF: There is so little exposure for so much of the audio work that is included in the AR's archives that the more the CDs are being broadcast, the better. It's intended to be used, not just displayed. We recognize, however, that interactive projects in galleries and museums are often subject to a great deal more handling and abuse than they can sometimes withstand. Seeing "out of order" signs on exhibits is always depressing.

We admire Brennan's design and craft of the AR—it is a beautifully built aesthetic object with a design that holds up even when it's not in use. But part of that beauty comes from seeing it function. Even unconventional uses can be wonderful. We observed gallery tech workers putting the AR to great use in Weimar, Germany, at the ACC Gallery. They used it to play their own CDs rather than the ones in the archives. They placed radios throughout the gallery rooms so that they could listen to transmissions of their favorite rock and reggae CDs all over the building while they were painting the walls. This deviated from the AR's intended function, but it was still nice to see the workers capitalizing on its ability to transmit.

Now that so many people have laptop computers, there could be other possibilities. Perhaps people could simply bring their computers to the gallery or museum and import CDs from the AR's archives into their computers. They could then share the

Brennan McGaffey, Drawing for *Audio Relay*, 2005
Digital graphic

sound files using Peer-to-Peer File Sharing. Here, the storage capabilities of the AR could be put to use and a different kind of transmitting could be enabled without ever turning on the AR's transmitter.

SS: Could you talk about how this project relates to Temporary Services' other mobile archive project? Or to Temporary Services' ideals and practices as artists?

MF: The AR is a tool that gives us another means of bringing creative work to broader audiences than experimental culture often enjoys. We feel it is vital that artists and other creative people develop new and imaginative means of bringing their own work and the work of others out into the world. The AR is an effective way for us to share some interesting audio projects that deserve greater exposure. Radio is terrific for sharing sounds and information.

The AR is also quite practical to ship and use in other countries. It allows many under-recognized people with CDs in the archives to piggyback onto exhibition opportunities that may happen for Temporary Services or Brennan.

BB: We are constantly moving between different contexts and modes of working. We will work in a museum or cultural center but just as easily broadcast out of our apartments or Mess Hall, the autonomous space in Chicago that we run with five other people. The AR can be a radio station when it is not being presented as an art project. It is very hard to control and can be moved rapidly. We like this aspect of the project, as it is one of many means toward building our own culture that can't be shut down by dominant powers.

April 2005

Audio Relay, 2002 (First manifestation)
Installation at Temporary Services'
event *Winter Services*, 2003

NILS NORMAN

Opposite: *Ideal City,*
Research/Play Sector, Chicago,
2005 (detail)
(CAT. 12)

Mountable Turbine

Internet Antenna

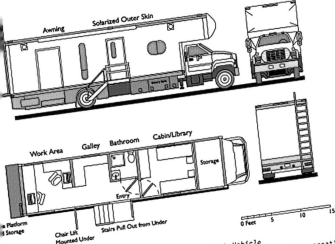

Awning Solarized Outer Skin

Work Area Galley Bathroom Cabin/Library

Storage

Entry

Platform
Storage

Chair Lift Stairs Pull Out from Under
Mounted Under
Carriage

0 Feet 5 10 15

The Solarized Hydrogen Powered Public Space Research Vehicle
The reclaimed film production unit has been converted to hydrogen power creating
a zero emissions 'clean energy' vehicle, enabling two researchers/artists to study
and observe public spaces across America, these include parks, squares, malls,
streets and markets. Onboard sleeping and kitchen areas allow for long road trips
and visits.The work area consists of a library, archive and study station with remote
internet access. Filming and recording instruments are stored onboard as well as a
temporary exhibition and film screening setup. An outer solar skin converts light to
electricity, powering all onboard electrics. There is also a weather station
and viewing/surveillance deck.
Other possible areas of research are Utopian community sites (past and present),
experimental communes, alternative farming/gardening projects, urban agriculture,
permaculture centers and squats.

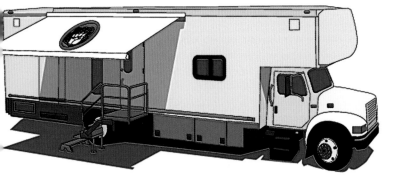

Nils Norman explores ways

that urban regeneration efforts often homogenize public space and searches for alternative approaches. He draws on past and present utopian experiments in the United States and Europe, as well as activist tactics for urban intervention. Norman creates artists' books as well as drawings, models, and murals that blur boundaries between art and design. He has transformed some of these proposals into functional objects and structures but frames his practice primarily as an investigative and speculative endeavor.

For *Beyond Green*, Norman created a new mural-sized, brightly colored banner. The central part of this fantastic landscape presents structures culled from his research on "adventure playgrounds"—a term used to describe vacant lots in Britain that have been turned into lively public spaces through community and child-centered design processes. Norman combines structures from different playgrounds to envision an idealized playspace and emphasizes its utopian possibilities through the inclusion of faceted geodesic domes like those designed by the visionary architect and engineer Buckminster Fuller. "Notebooks" flank this space and present ideas for two possible mobile structures. One shows Norman's designs for "The Solarized Hydrogen Powered Public Space Research Vehicle"; the other depicts simple, portable water filtration systems that could be built primarily from cast-off materials and used to purify wastewater. The artist presents these projects in different representational strategies, ranging from didactic (the notebooks) to architectural (the play structures) to cartoonish (the gloved hand). The surreal blend of visual styles and structures, set within a landscape in which grass becomes a comic-book parade of acidic drips, suggests a certain skepticism—or maybe just a dash of black humor—about the possibility of actually implementing any of these progressive structures on a wider scale.

During fall 2005, Norman explored related ideas with University of Chicago students during a residency during which he taught an interdisciplinary course, "Spaces of Utopia: Contemporary Arts and the Environment." This nomadic class used the city as its classroom; as Norman notes, it was "designed to function outside of the traditional classroom space. An experiment in interdisciplinary education, the class investigated the production of social spaces and considered the city as a multitude of ecologies. It included field trips to parks, gardens, arts spaces, and official environmental initiatives and their self-initiated, community-based counterparts or 'parallel' sites."

Above left: *Ideal City, Research/Play Sector, Chicago*, 2005
Printed vinyl mural (CAT. 12)

Above right: Michael Rakowitz's *(P)LOT*, 2005
Commercially produced automobile cover and portable framework
Installation view at Smart Museum of Art

Interview

Stephanie Smith: You often use large banners as a means to convey your ideas. Why?

Nils Norman: I use the computer graphics program Adobe Illustrator to make digital drawings that can be easily enlarged or reduced to pretty much any size without losing resolution. So postcards, leaflets, posters, banners, digital wallpapers, and billboards are very simple and fast to produce, making it a mobile, autonomous, and immediate way of working. I usually look at the site where the work will be exhibited, taking into consideration budget, architecture, type of exhibition, outside space, city space, etc., and then try and formulate an appropriate format that will work within those parameters. I am trying to explore the idea of these projects being forms of propaganda in terms of aesthetics and content.

SS: The wooden structures that you depict in the back of your mural for *Beyond Green* remind me of the adventure playgrounds that you documented in your book *An Architecture of Play: A Survey of London's Adventure Playgrounds* (2004). (Adventure playgrounds are neighborhood playscapes built in vacant lots in London beginning after World War II and often designed by, or in close collaboration with, children.) How do the adventure playgrounds relate to the other images gathered into this work?

Nils Norman: Over the past four years, I've researched adventure playgrounds as well as makeshift architecture and ideas that revolve around the concept of "Non-Plan" planning. Non-Plan is an idea that was floating around in the 1970s and 1980s that experimented with the idea of taking a city area and removing all planning regulations, enabling local people to design and build whatever they wanted. It was seen by many as a highly conservative approach to planning, but its links to the squatters' movement and the idea of autonomous zones is very interesting. I have come to see adventure playgrounds as radical models of alternative public space—playful spaces of disruption, disorder, and undevelopment in direct opposition to the relentless privatization and dismal redevelopment of every sad scrap of urban space. Manhattan, for example, is still a vibrant and diverse city space. However, Business Improvement Districts (a form of privatization and gentrification in which the government creates partnerships with the private sector that are designed to improve business in different city areas) and other private initiatives have radically altered the city's character; it has become more homogenous, with less disruptive space.

SS: One of the central images in the banner you are designing for *Beyond Green* is a bus that you imagine transformed into a sustainably powered research vehicle. Could you talk about how this idea fits into your prior designs for research vehicles? For instance, do you hope to actually construct and use the Public Space Research Vehicle as you did the *Geocruiser* (2001), which started as drawings, plans, and models but was eventually built through a commission by the Institute of Visual Arts in London?

NN: The research vehicles I have been designing are mainly fantasies. A couple of years back, I went on a research tour related to the Lebens Reform (Life Reform) movement, traveling with my friend, the German artist Stephan Dillemuth. This was a movement that formally began around the mid 1890s. It was a reach toward a new way of living, a kind of proto-hippy experiment that encompassed many things to do with health, nutrition, dwelling, and clothing. They were the early vegetarians, naturists, and organic farmers. We toured museums, historical commune sites, farms, garden cities, and

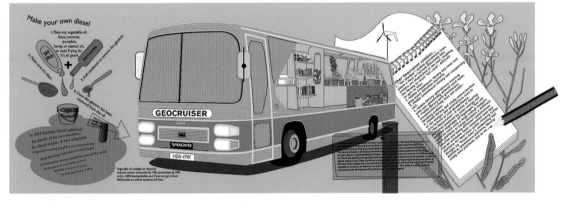

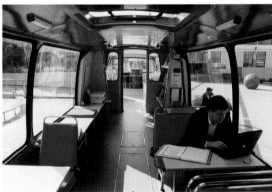

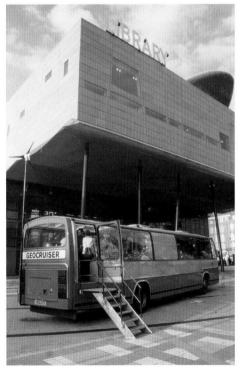

Above: *Geocruiser Billboard*, 2003
Digital graphic
Below left and right: *Geocruiser*, 2003, interior and exterior
views outside Peckham Library, London

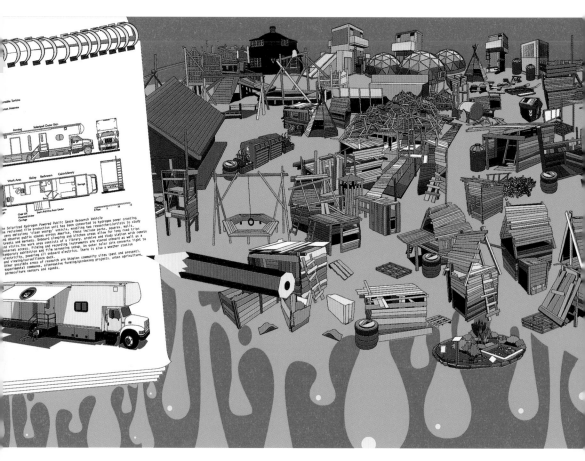

Solarized Cloister Ship

Awning

Work Area Galley Bathroom Cabin/Library

Storage

Chair Lift
Housed Under
Carriage

Stairs Pull Out from Under

The Solarized Hydrogen Powered Public Space Research Vehicle
This reclaimed film production unit has been converted to hydrogen power creating
zero emissions 'clean energy' vehicle, these include parks, squares, malls,
and observe public spaces across America. enabling two researchers/artists to study
streets and markets. Onboard sleeping and kitchen areas allow for long road trips
and visits. The work area consists of a library, archive and study station with remote
internet access. The work area consists of a library, archive and study station as well as a
temporary exhibition and film screening setup. An outer solar skin converts light to
electricity, powering all onboard electrics. There is also a weather station
and viewing/surveillance deck.
Other possible areas of research are Utopian community sites (past and present),
experimental communes, alternative farming/gardening projects, urban agriculture,
permaculture centers and squats.

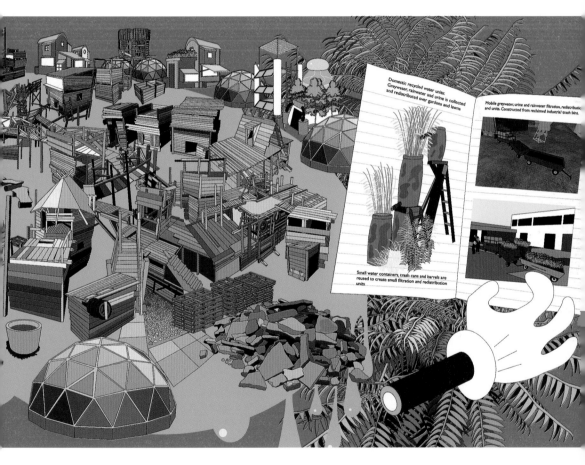

Ideal City, Research/Play Sector,
Chicago, 2005
Printed vinyl mural
(CAT. 12)

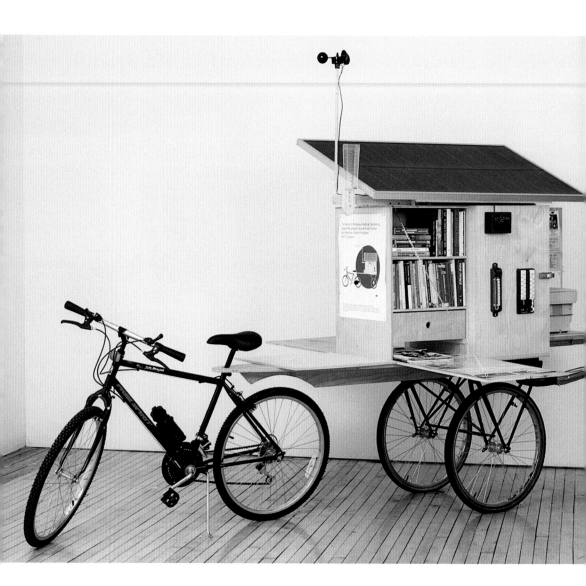

The Gerrard Winstanley Mobile Field Unit
(Prototype NYC), 1999
Mixed media installation
Installation view at American Fine Arts
Co., New York

archives from Hagen in northern Germany to Lago Maggiore in Italy. We drove around in a very small sports car, and if we had had a hydrogen-powered, mobile live-in work-station, our trip would have been perfect.

The Public Space Research Vehicle is really just a proposal; I'm more interested in the ideas and research rather than the vehicle itself. The vehicle is just a framing device through which to view the content: uses of public space and the history of U.S. utopian experiments in agriculture, economies, and communal living.

SS: If you were to use the Public Space Research Vehicle, what sites would you visit? What kinds of utopian communities are you most interested in these days?

NN: I would visit all the utopian communities I could find, from the Earthships in New Mexico to Brook Farm, Massachusetts. Garden city experiments and urban farming initiatives would also be important stops, as well as any remaining squatted buildings in the U.S.

SS: This fall, you're going to be in residence here at the University of Chicago teaching a course on environmental activism and contemporary art that's going to be an almost entirely mobile, field trip-oriented class. Could you talk about that course and the relationship between your art and your interest in radical pedagogy?

NN: The course is based loosely on an idea the anarchists Colin Ward and Anthony Fyson formulated in the 1970s, in which all the classes occurred outside in the city. Their idea was to enable high school kids to start thinking about and even possibly implementing urban planning ideas themselves, in an anarchistic, do-it-yourself style. In Chicago we have ten weeks and ten trips in and around the city, visiting different alternative ecologies: economic, environmental, and communal experiments. Artists are now inescapably inscribed within urban regeneration strategies, and in order to start thinking about this bind critically we need to begin creating more disruptive and exper-imental methodologies, not just "neo-situationist spectacles," which is how I see a lot of artist interventions developing. It is also an attempt to imagine the city as a multi-tude of ecologies and alternatives.

SS: How important is your art training to the work you do now? You mentioned once that you were part of a transitional generation in art school, so you had conceptual training and also learned how to draw.

NN: My education at St. Martins College of Art and Design, in Soho in central London, was interesting (1986-89). Our generation was on the cusp of change, from a more traditional formal art education to what we have now, a more interdisciplinary peda-gogy. At St. Martins it would have been better if the institution were given over to the students for three years; it was the location and the other art and fashion students that made the school interesting. I left for Cologne the summer I graduated, and I learned more there about site-specificity, politically engaged practice, and the use of irony as a discursive and critical tool in art making.

On a general note, my practice as an artist is informed by ecological models and ideas, but this is only one small part of my practice—I don't regard myself as an "eco-artist" in any way. I am focused on issues that are threaded through public space and urban regeneration. Ecological issues are one thread or one ecology amongst many.

June 2005

PEOPLE POWERED

peoplepowered

Opposite: *Loop: Multipurpose
Coverall*, 2003 (detail)
Quart can, printed label, and 100%
postconsumer recycled paint

loop: MULTI-PURPOSE
COVERALL

Artist Kevin Kaempf, who works

under the name People Powered, has adopted a small-business model for his art practice. Operating with this "brand identity," he creates small-scale public art interventions that offer simple solutions to problems of sustainability within daily urban life. All of his projects bear the energetically off-key People Powered logo, and he mimics corporate marketing and branding tactics as a means to attract wider participation in his projects.

Transport I, a new installation created for *Beyond Green*, consists of a shipping and display unit that documents People Powered's composting and paint recycling programs, *Soil Starter* (2002–ongoing) and *Loop* (2003–ongoing). The installation includes samples from these projects; instructional, documentary, and marketing materials; and a set of do-it-yourself instructions that visitors can download from a computer, print onto waste paper, and take home.

Soil Starter is a small-scale composting network that Kaempf created for city neighbors who want to compost their kitchen and yard waste but don't have the space or the inclination to do it themselves. He periodically collects and composts this organic matter, and then delivers "tea bags" back to the participants. These translucent packets contain composted matter that releases nutrients when watered (ideal for malnourished urban houseplants).

Loop deals with another common phenomenon: the cans of half-used paint that accumulate in our closets, garages, and workshops as we redecorate our homes and offices. Kaempf collects paint from friends, strangers, and institutions, combines it into new colors, and attractively repackages and distributes the paint as "Loop: Multi-purpose Coverall." All of the venues presenting this project are encouraged to save their leftover paint for a period of time leading up to the exhibition and to collect additional paint from other people and institutions in their communities. Following Kaempf's instructions, each venue may then mix this paint and use it to make a site-specific wall painting. The painting is then adorned with color swatches from each color of donated paint: stand-ins for the individuals—or at least, the individual colors—that have created this new hue. Extra paint goes into quart cans labeled with Kaempf's *Loop* and People Powered graphics and is distributed by each venue at the close of the exhibition.

Transport I takes People Powered's projects on the road, introducing new audiences to Kaempf's sustainable processes and perhaps spurring them to action. If this occurs, it will be due to some mix of existing needs among potential "consumers" of his processes, the clarity and ease of Kaempf's systems, and the visual appeal of his design sensibility: Kaempf not only provides solutions to everyday problems but also attractive, contemporary packaging. People Powered's processes provide catalysts for change in the behavior of small networks of people while embodying actual material transformation as things move through cycles of use and reuse.

Opposite: *Transport I: Loop and Soil Starter*, 2005
Wall installation with recycled paint and paint swatches; wood case with stool, computer equipment, metal cans, and sample kits made of biodegradable plastic encasing inkjet prints, paint sticks, paper, soil, and organza
Installation view at Smart Museum of Art, University of Chicago
(CAT. 13)

Interview

Stephanie Smith: How did you get started with People Powered?

Kevin Kaempf: After leaving graduate school and moving to Chicago in 1999, I wanted to integrate a number of my interests. The process of making art for gallery exhibitions felt separate from my other interests in design, biking culture, and environmentalism, and I wanted to develop a set of parameters for an art practice that could integrate them. In particular, I wanted to use art and design as a format for communicating about environmental concerns and making change.

SS: In terms of design, were you interested in updating the aesthetic sensibility of environmental products and ideas?

KK: Definitely. For me it felt like many of the available environmental resources—like the books or Web site that offer information on researching composting or organic gardening—were completely related to the hippy granola aesthetic of the 1960s and 1970s. While I have an interest in that aesthetic, I started thinking about updating it and about merging sustainable strategies like recycling, composting, and organic gardening with a contemporary consumer aesthetic. I'm not alone in thinking about this; other artists are working in this way, and it is a trend in the commercial world as well.

SS: That's one of the premises of People Powered: you've created a set of simple strategies or pilot programs for solving problems on a local level—in *Soil Starter*, gathering and composting kitchen waste for your neighbors; in *Loop*, collecting, blending, and redistributing leftover paint—and then you mimic slick corporate marketing tactics as a means to package and disseminate a set of practices that have a socially useful end. And you frame the whole thing as part of your art practice, which I want to get back to in a minute. First, though, as part of your preparation for People Powered you researched corporate branding strategies and logos. Which of the ideas or strategies that emerged from this research were particularly useful for you?

KK: As someone outside of the rhetoric of advertising, I was fascinated by marketers' ideas about community: by identifying the allegiances of the consumer, they foster an idea of brand loyalty that makes a connection with a product or a company into participation in a community, which still somehow is based on your own individuality.

SS: That's a common enough advertising technique: make individuals feel that a product affirms their unique identity and discerning taste but simultaneously links them to a group with which they want to be aligned. So, you were looking at this strategy more critically from your perspective as an artist and then appropriating it into the development of the People Powered brand.

KK: I especially wanted to infuse the visual language of corporate advertising with a notion of community that's based on something more meaningful than marketing strategies. Part of that developed from the crazy feeling that I was getting from seeing how so much "connection" happens through acts of consumption among people who are not our immediate friends and family. With the People Powered projects, I decided to take this on in a small-scale, grassroots way by building community within my own limits. Those limits include the physical limits of my neighborhood and also the limits of my personality, since I'd never really put myself in this kind of situation prior to this

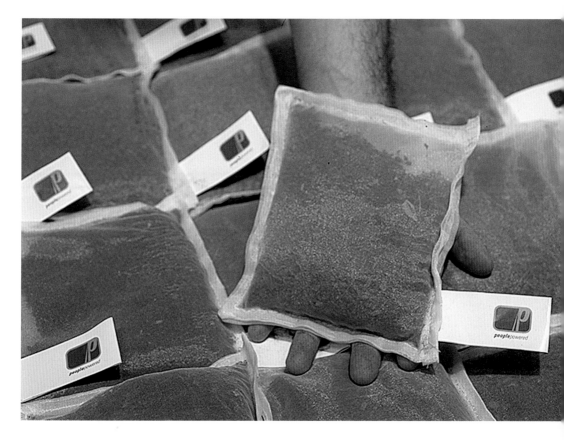

project. As the artist/designer of *Soil Starter*, for instance, I'm able to access friends and friends of friends and develop this small-scale composting network, which challenges me to put myself out there and also puts me into contact with people who may not initially have any interest in this as an art project.

SS: How do you talk about *Soil Starter* to the people who aren't interested in it as a work of art?

KK: I leave room for people to be engaged in whatever way they like. There are several different levels at which the piece functions: it recycles material, and it also functions metaphorically as a work of art that transforms materials, frames ideas, and makes a concrete gesture that models ways that others can develop creative solutions to the problems that they might passively hope someone else is going to take care of.

SS: Do you feel that your identification as an artist gives you latitude to pursue socially engaged projects in ways that you might not be able to if you were working directly as an activist?

KK: There's definitely something that happens when a visual artist works within another discipline as part of their process. We don't necessarily come up with the best solution to the problem that we're trying to frame, but on occasion we come up with something great because we're not so close to this other discipline.

Soil Starter, 2002 (detail)
Organza, printed tag
with instructions, and
compost

SS: Is there a way that you see that happening in your own process in relation to *Soil Starter* or *Loop*?

KK: On a practical level, I completely ignored the bureaucracy that usually hampers this kind of activity if it is labeled as an officially sanctioned project, such as the need for clearly defined objectives for the programs. I started the *Soil Starter* project with the simple question, "What if I started collecting kitchen scraps from friends to compost?" As an individual artist, I had the privilege to try these projects without having all of the kinks worked out. Eventually I arrived at one possible solution to a problem that we have in Chicago (and in many cities). I would encourage others to work this way; I'd like to see more individual citizens trying something out and not waiting or hoping for some other group, whether it be the city government or some loosely organized activist group, to offer up a solution.

SS: Could you describe your new work for *Beyond Green—Transport I*—and your plans for it as a means of shipping/disseminating/marketing your projects? Ideally, how do you hope the institutions presenting the exhibition and the audiences who visit it will engage with the work?

KK: *Transport I* is a self-contained display for the projects *Soil Starter* and *Loop*; the booths and display systems you might see at a trade show or an expo influenced its design. Ideally, I'd like to find opportunities for it to be exhibited in different kinds of venues, in addition to the art exhibition context. The display includes all of the ephemera you would need to start one of these pilot programs in your own community: instructions, materials, and tools. By laying all of these out, I hope it will illustrate just how easy (or difficult) it can be to implement your own local composting network or paint recycling project.

SS: Could you elaborate on that last point? What are some of the challenges you've encountered with these projects or with your practice in general?

KK: I don't want to idealize the projects or romanticize the labor involved in them. This is one reason that I realized the pilot programs rather than making a hypothetical project or proposal. By initiating these small-scale projects, I have learned just how difficult it can be to get something like this started. It requires a lot of back-end work in planning the logistics of collection and processing the materials. I have taught myself a process for this by trial and error. Based on my experience, I was then able to develop the framework for someone else to try it out.

One challenge with my practice in general is that I really get absorbed by the active recycling programs. I enjoy the planning and the execution of the programs and interacting with the people who provide paint and compost materials. However, this is only one half of my practice. The other component of the project is "the art part"—creating and framing the projects for an art context. Balancing my interest in both these arenas has been a challenge.

SS: Do you think the pieces will lose any of their punch once they move out of these small-scale local networks as the work travels? Will they gain anything from these new contexts?

KK: The work could gain or lose punch depending on where it is presented. The projects initiated in Chicago are a direct response to the lack of infrastructure in place for

adequate community recycling. Certainly the city government here is trying to address this, and they are making headway. But we as citizens may be able to organize and develop possible solutions much more quickly, although on a smaller scale, than city government could.

San Francisco has a paint recycling program and collects compost curbside. So obviously these specific pilot programs are less relevant if exhibited in a city where these issues are addressed by the city government. However, the projects still resonate on the metaphoric level of addressing waste and overconsumption in our culture.

SS: How do you see your work fitting into current art practice?

KK: Artists have always included in their work ideas and issues that arise from the culture, which is what I feel I am doing. That being said, is there a trend or movement in current art practice which is fully embracing or incorporating environmental concerns? Well, I do think this is happening in many aspects of our culture—in art, product design, architecture, government policy, school curriculum, even at the office I work in, where recycling has become a topic of interest.

SS: How do you see *Transport I* relating to or pushing against notions of sustainable design?

KK: Apart from the content of the two recycling projects themselves, the piece relates in the way that I am considering how it will travel during the exhibition tour and incorporating that consideration into the design. It immediately made sense to me to have the crate open up into the display. In this case, it certainly did not seem appropriate to make a display and then make a separate crate to ship the display from location to location. That picks up on one of our initial discussions about the exhibition, when we decided that each venue would have the opportunity to implement *Loop* by recycling its own paint. The idea of shipping paint around from the Chicago version of the paint program just seemed absurd.

SS: In conjunction with the exhibition's Chicago presentation, you will be teaching a summer course for high school students participating in the University of Chicago's Collegiate Scholars Program. Please tell me about that project and how you see it relating to the exhibition.

KK: The course is about exploring the diverse forms with which contemporary artists deploy politically engaged messages. Specifically, we will be looking at the rich history of Chicago artists creating works that frame socially relevant issues such as housing, social justice, organized labor, and environmentalism. Sometimes what the artist comes up with doesn't really resemble what we might think of as visual art, and sometimes it doesn't really relate to our idea of what activism is. In *Beyond Green*, there are a number of artists touching on disciplines outside of visual art and in essence designing possible answers to questions from that area of expertise. Our answers to those questions are at times very impractical, but they also allow for an opening up of the problem-solving process that can be very liberating. This is something I really relish, the problem-solving skills that can be developed and refined through training in visual art.

April–May 2005

DAN
PETERMAN

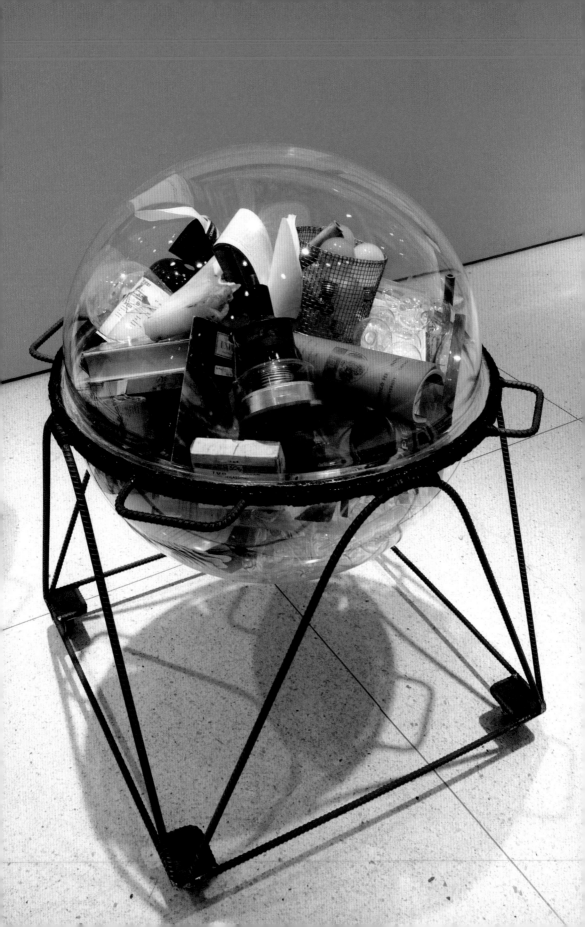

Since the late 1980s

Dan Peterman has intervened into the systems through which ideas and materials circulate in contemporary consumer culture. He often uses postconsumer reprocessed plastic or retooled found materials in his sculptures and installations.

For *Beyond Green*, Peterman has "recycled" an existing installation entitled *Excerpts from the Universal Lab (plan b)*. This work originated as a site-specific commission for the Smart Museum's 2000 exhibition *Ecologies: Mark Dion, Peter Fend, Dan Peterman* and has since been reconfigured into new projects for other exhibitions. All of these versions of the project use objects from an actual place, a now-defunct scientific laboratory formerly housed in a warehouse on the south side of Chicago. At the Universal Lab, a group of amateur scientific researchers gathered discarded items that they had scavenged from the University of Chicago's laboratories and loading docks and used these materials for their own research. Eventually the space became clogged, the operation closed its doors, and in 2000 its contents were almost discarded by the building's new owners. Peterman and others intervened and helped save and reuse many of these materials, some of which returned to the University of Chicago as artwork, went through the inventory process, and took on a new life as sculpture.

In this latest iteration of the Universal Lab, created for *Beyond Green*, Peterman has sorted some of this detritus into new, much smaller groupings contained within a series of elegant, rolling vitrines that evoke laboratory carts, globe stands, museum display cases, and sci-fi machines. The mobility of these carts echoes the nomadic nature of the objects they contain, which have accrued new layers of meaning and value as they have traveled from an initial functional life through several cycles of use and reuse. In addition to reusing materials, this project calls into question the art world's persistent demand for new work and the consumption of resources that this production requires.

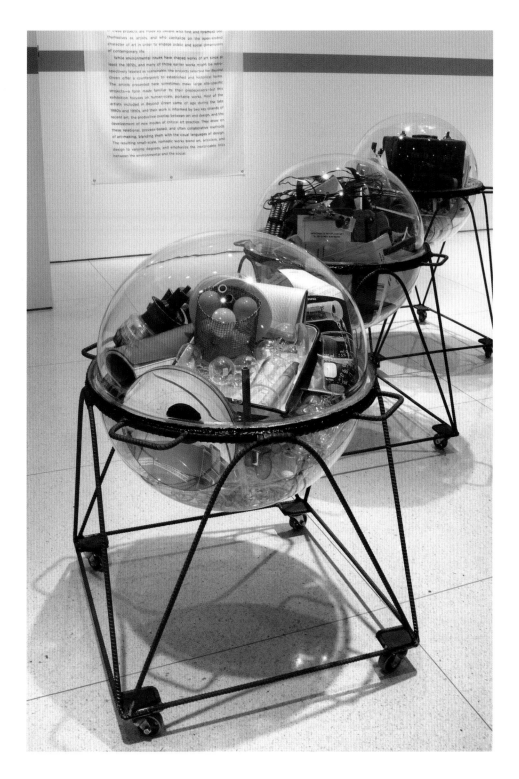

*Excerpts from the Universal Lab
(travel pod #1, #2, and #3), 2005*
Assorted materials in plexiglas spheres on wheeled metal supports
Installation view at Smart Museum of Art, University of Chicago
(CAT. 14)

Statement

Simultaneously a utopian research model, a reservoir of scientific lab equipment, a waste handling/reuse/storage dilemma, and, to varying degrees, an art project, the Universal Lab continues along its unique, hybrid trajectory. Since its inclusion in the *Ecologies* exhibition at the Smart Museum of Art in 2000, *Excerpts from the Universal Lab* has appeared in two prominent museum exhibitions; spent a year trapped in a U.S. Customs storage facility, where it narrowly escaped destruction; been the subject of a threatened lawsuit by its former landlords; and spent two additional years in a semi-trailer. The art world has played gracious host to the sprawling, rambling collection of matter that is at the core of this project but has not yet entirely gotten its arms around it. It seems to fit in catalogs, and briefly in large exhibition spaces, but not the storage lockers of permanent art collections. But the reluctance of art institutions and collectors to take that kind of plunge is understandable, and, I think, speaks to the heart of the matter.

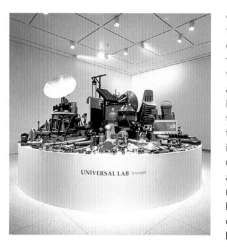

UNIVERSAL LAB (excerpt)

It is the scale of the original collection that continues to energize Universal Lab. Within that enormity, a continual shift in polarities occurs between waste and resource value and valuelessness; historical relevance and triviality; sublime attraction to the senses; and grand annoyance. The Universal Lab has always felt like something larger than life, something that never should have existed at all, something utterly unregulated that grew quietly in the shadow of extreme regulation. It is the unlikely convergence of three things: the exaggerated, post–Manhattan Project, Cold War research budgets at the University of Chicago; human energy, measured in decades, dedicated to moving remains of those research budgets, around the clock, from point A to point B; and finally, abundant, nearby, affordable, unscrutinized warehouse space. The scale of each of these forces is what transformed the Universal Lab from a flawed, impoverished scientific research offshoot into something much more deeply, and humanly, compelling.

But it is this scale that has also fed the urgency behind uprooting it, evicting it, and, in the end, regulating it. The Universal Lab, in its current state, has been brought down to size. Rather than the negligent, hazardous, wholesale disposal process launched by its landlords in 2000, intervention by the Resource Center (a Chicago-based nonprofit) and volunteers over subsequent years has allowed for large amounts of its contents to be recycled, reused, or resold. In 2002 the University of Chicago stepped up and handled all radioactive materials with great care and concern, but after this brief period of cooperation it denied any obligation to address other hazardous materials. In 2003 the chemical inventory was at least partially identified and disposed of under professional supervision, at significant expense to the landlord. In early 2004, the 10,000 square feet

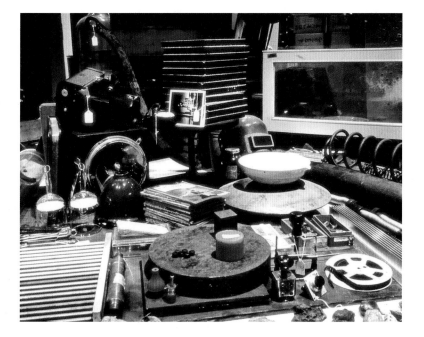

of space that the lab had occupied since the 1960s was finally cleared, again at signifi-cant expense to the landlord. But this does not mark the end.

The semi-trailer load of materials from the Universal Lab had previously been drawn off from the main body. A rough estimate would place these excerpts at between one and two percent of the whole laboratory, and, other than the absent chemical stores, they are fairly representative of its contents. This roving, satellite collection, moving in and out of trucks, art museums, shipping containers, loading docks, and warehouses, has become the mother ship. As they continue to drift, shrink, and adapt to their con-dition of permanent mobility, the excerpts may hopefully, once again, find an anchor point from which to grow. In the meantime, the logistics of travel and storage are increasingly influencing their scale and shape. In this return orbit through the Smart Museum and other venues, as excerpt of excerpts, the process of further compartmen-talization and streamlining will be evident.

Perhaps this is just a sign of fatigue. Hopefully, it's a sign of something more. I'd like to think that a latent survival mechanism of the Universal Lab is kicking in. Maybe it's here for good reason, once again knocking on the museum door, seeking asylum, near the nurturing loading docks that first gave it life.

April 2005

MARJETICA POTRČ

*Opposite: A Hippo Roller for Our
Rural Times*, 2005 (detail)
(CAT. 15)

Marjetica Potrč focuses

on the ad-hoc architecture and objects made by the residents of "informal cities," a name she has given to the impromptu residential areas that exist around the edges and in the shadows of global metropolises. She studies how people around the world, living under these conditions, are solving specific problems without support from official sources: on their own terms, on their own time, and often outside the bounds of the law. She usually works in a case study mode in which she makes this necessary, everyday creativity visible within the gallery space. Her best-known methods include sculptural installations in which she re-presents "urgent architecture" in the form of temporary sculptural installations, and two-dimensional works that combine text and image, including photographic collage and her signature brightly colored, loosely rendered drawings.

Potrč's contribution to *Beyond Green* comes from her ongoing series *Power Tools*, in which she applies her case study approach not to architecture but rather to small-scale objects that she has culled from the usually undifferentiated stream of consumer goods. The Hippo Water Roller featured here, made by the company Imvubu Projects, allows individuals to efficiently move large amounts of water over long distances. Potrč presents it along with a print that indicates some of the social benefits of its adoption. The full *Power Tools* series examines other commercially produced objects such as solar-powered flashlights and clockwork cell phones designed for use by residents of the informal city or "urban explorers" as well as by those in rural areas. These devices apply sustainable design strategies such as durability and self-power (through body movement or solar power, for example) to real social needs such as lack of easy access to electricity or running water. (Of course, the boundaries between necessary object and luxury item are fluid as things move among different contexts, and Potrč has observed that the clockwork cell phone has been picked up as a trendy gadget by Johannesburg urbanites.) Through her visual and verbal commentary, Potrč calls attention to the huge variety of applications of sustainable design and its varied roles in different social contexts.

Opposite: *A Hippo Roller for Our Rural Times*, 2005
Utilitarian plastic and metal object, and printed
drawing (inkjet print)
Installation view at Smart Museum of Art,
University of Chicago
(CAT. 15)

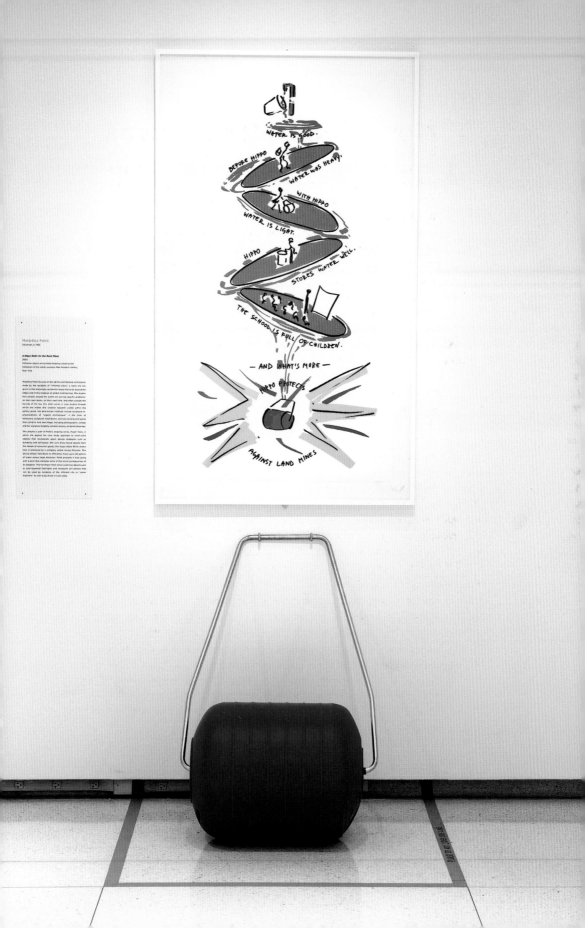

Statement: Temporary Territories

At the Kunst-Werke Café

Two weeks ago, on a rainy afternoon, I was sitting in the Kunst-Werke Café in Berlin with Kyong Park. We were talking about cities in the Balkans. Should we make a research trip there? The autumn rain was pouring against a glass wall and transforming the pavilion where we sat into a kind of island, a Berlin island. I thought, what is it that draws me away from islands—to walk through cities no one else seems to care about and some might be afraid to visit? I still remember the e-mails I received, back in the spring of 2003, cautioning me not to go to Caracas. At the time, I wondered whether I would be able to tell the stories of a city in crisis—I mean the stories embedded in its architecture. Would people back home understand narratives that did, at first glance, not appear to concern them? Now, looking back at my Caracas experience, I feel that the opportunity to study the city was an extraordinary gift, one that has helped me better understand the cities I love.

A number of my recent projects had their start in Caracas. I am most proud of the Istanbul and Liverpool projects, which were realized recently. I consider the *Dry Toilet*, constructed on site in a Caracas barrio, and the *Urgent Architecture* exhibition, which I dreamed up with Michael Rush, then director of the Palm Beach Institute of Contemporary Art in Florida, to be the best work I have ever done. The PBICA exhibition gave body to recent trends in contemporary architecture, such as the emphasis on private space and personal security—remember, it is individuals who make a city and it is their concerns that matter. For me, the most important thing about this exhibition was the attempt to construct an understandable language out of the apparent madness of cities in crisis. After all, the architecture of such cities tells vivid stories, since reality seems somehow enhanced there. Caracas has served as a case study for my cities. Look at Berlin, of all places; here I sit and all is well—today.

The City of Caracas

The city's underground passages were full of people pressing onward, and always too close to my body. Above ground, the city weighed heavy. It was noisy and loud, and never slept. It was smelly and dirty. The tropical rains, which unleashed a pure natural energy, seemed to be the only thing able to calm the city down and give me a chance to catch my breath. Caracas is a pagan city. I felt its raw energy smelling of survival in the midst of individuals who stake their claims to happiness in an apparently collapsing city. Never walk through the narrow alleys of La Vega barrio alone. In the formal city, always take a taxi after dark. Push down on the gas pedal when the light turns red. Never stop at a traffic light at night, especially when you are driving alone. You must always be present in both mind and body, but above all listen to your instincts. Never plan anything. Events impose themselves on you easily in Caracas, whether crimes, floods or celebrations. I found that, once I had arrived, this dangerous and divided city would not let me go.

I came to Caracas in order to research the informal city,[1] which is one way of referring to the barrios of Venezuela. In Caracas, this informal city, climbing up the hills, encircles and presses in on the formal city, which occupies the valley below. The

1. This research was carried out in 2003 as part of the Caracas Case Project and the Culture of the Informal City, sponsored by the Federal Cultural Foundation of Germany and the Caracas Think Tank.

communities that inhabit the two cities are alien to each other, with different value systems that breed a mutual mistrust. They coexist in close proximity, however, and must constantly accommodate each another. The divisions in Caracas are unmistakable. I had no problem accepting this fact, the permanence of this division. When you think about it, the finality of the division is, more or less, the only thing that is really permanent in Caracas. Everything else exists in a flux of decay and expansion in the midst of permanent crisis.

The formal city, once a proud modernist town, was now in decline and fast becoming a modern ruin. It seemed to me that it was losing its body as well as its mind, wildly and without regret. Oversized billboards, sometimes bigger than the houses they were built on, were left empty. The Parque Central building complex, once the pride of Caracas modernism, was deteriorating and being overtaken by nature. Built-on additions and vegetation sprouted from its monumental façades. The ground floor shopping mall was deserted, with barred windows barricading the shops. The elevators were not working. Parque Central seemed consumed by its own malaise and had apparently abandoned modernism's quest to display the values of functionalism and consumer society. Parque Central's demise felt almost biblical. Or did it? A block away, the Urban Agriculture Cooperative occupied a former public park. Red peppers and lettuce were growing in green fields and were being sold to passersby. Those who lived in the vicinity viewed the urban farm as an invasion of the rural into their urban landscape; the barrios, too, were considered a form of rural architecture, an alien growth in the modernist city. Though the barrios were not as nearby as the urban farm in the park, they were constantly present. From virtually anywhere in the formal city, you could see the outlying hills populated by barrio communities. Who were those people and why did they persist in invading the modern city with their urban farms and informal marketplaces? They had arrived in Caracas from the rural hinterland and had stayed, becoming the construction workers who built the formal city by day and their own city by night. The barrios are not planned settlements; they were created by individuals who built their homes on public land without obtaining any permit or title. These homes are self-initiated structures that have been upgraded and expanded as need arose. In Caracas, the barrios are growing, not decaying, and they exude a confidence in their own body. This is a rural architecture made of tightly interwoven buildings and alleys. The people who live in the barrios had prevailed against all odds, growing their houses as their families grew, shamelessly showing off this growth with construction wires that sprouted from every rooftop. This ephemeral city was clearly here to stay.

Caracas: *Dry Toilet*

The *Dry Toilet* project was the result of a six-month stay in Caracas, during which time the Israeli architect Liyat Esakov and I researched the informal city under the auspices of the Caracas Case Project. A dry, ecologically safe toilet was built on the upper part of La Vega barrio, a district in the city without access to the municipal water grid. The project attempts to rethink the relationship between infrastructure and architecture in real-life urban practice in a city where about half the population receives water from municipal authorities no more than two days a week.

As it often is with the best things that happen in life, I never expected that I would one day be building a dry toilet in a Caracas barrio. In our collaboration for the Caracas Case Project, the Israeli architect Liyat Esakov and I knew only that we wanted to work inside the informal city and not merely analyze it from a safe distance.

It was some time before we could actually walk through the alleys of the barrio. You always had to have an escort when you went there; it was too dangerous to visit alone. With the aid of Raul Zelik, another participant in the Caracas Case Project, we made contact with community leaders and were eventually shown around. Most importantly, we were able to discuss living conditions with barrio residents. What was most obvious, and most shocking, was the breakdown of the energy infrastructure and the lack of public utilities in the informal city. This was not what we had anticipated, since we were all focused on the fascinating and seemingly precarious architecture of the barrios. But we soon realized that the failure of the municipal infrastructure in the barrios was a logical outcome of the houses' construction process. In a planned city, the various forms of public infrastructure are set in place before construction starts. In the barrios, the houses are built first with infrastructure problems being dealt with later.

Liyat and I asked a group of barrio residents what they thought about self-sustainable energy solutions such as solar panels for bringing additional electricity to their homes. They could not care less. They were happy to steal electricity from the municipal power grid. They saw self-sustainable alternative energy technologies as something only rich people would be interested in. But drinking water was another matter, since it was provided by the city for only a few hours twice a week—if you were lucky. The upper part of La Vega barrio, where we eventually built the *Dry Toilet*, had no access at all to running water. This was a place ruled by necessity. Could barrio residents perhaps apply

Dry Toilet, 2003
Building materials and sanitation infrastructure
A collaborative project by Liyat Esakov and Marjetica Potrč
Supported by La Vega community, Caracas; the Caracas Case
Project and Federal Cultural Foundation of Germany;
and the Ministry of Environment, Venezuela

their survival strategies to utility infrastructures in a more focused way? Instead of shooting bullets into the municipal water pipes in order to get more water through an illegal water connection, they could take a different approach. Perhaps they could reduce their consumption of water. They would use less water if they had a toilet that did not need it. In this way, they would solve the infrastructure problem themselves, independent of municipal authorities. Our idea caught the attention of the community. The *Dry Toilet* made sense, after all. And so it was built by a team of construction work-ers from the community in La Fila, the upper section of La Vega barrio, on Raquel's property (if you can speak in this way about occupied public land); her house had never had a toilet before.

Barrio buildings are self-initiated and self-upgrading structures that function on a small scale. I still wonder why no one had previously thought to apply their strategies—their tropicalism, their nonlinear logic—on a city-wide scale. For Liyat and me, it was extremely important that Hidrocapital, the municipal water company, supported our *Dry Toilet* project. It made sense in a city where reservoirs were quickly losing water. For the La Vega community, the project provided a long-term sustainable solution for the prob-lem of waste water, radically reducing the community's water consumption. Houses collapse in the barrios not only because of the torrential tropical rains, but also because of leaking sewage. At one point Hidrocapital envisioned building full-scale models of the *Dry Toilet* in every municipality as an educational endeavor. Remember the urban farm in the middle of the formal city? This same cooperative considered erecting a *Dry Toilet* on its premises, but eventually decided against it out of a fear of controversy; the *Dry Toilet* might be seen as another invasion in the formal city simply because it can function on its own, without any connection to the municipal utility grid of the modernist city.

Looking back, I remember that Liyat and I both felt at home in La Vega barrio. Liyat eventually rented a room there and had to learn to bathe with only one cup of water. In a way, the *Dry Toilet* happened to us because we could see potential in an informal solu-tion. I cannot speak for Liyat, but my heart is instinctually drawn to individually initiated small-scale strategies, perhaps because I was raised in a socialist society. I have learned to have particular respect for the voices of individuals. Have Liyat and I romanticized the informal city? I do not think so. I am proud that we were able to draw attention to the shift from the power of institutions to the empowerment of individuals. In the con-text of Caracas, where the social state never really materialized, individual initiative is a natural route to take.

There is a certain humor in the fact that my project about informal Caracas ended up being the *Dry Toilet*. Or was it, perhaps, intuition that had made me build, way back in 1997, the *Core Unit*—a structure with a similar volume and content as the *Dry Toilet*—in the Landesmuseum Munster? This was the first case study I presented in a museum, and it proved to be a strategy I have followed ever since. I discovered the information behind the *Core Unit* in a *National Geographic* magazine. In Honduras, such units were part of the suburban housing program. A small building provided by municipal authorities was equipped with electricity, running water, and a toilet; residents would then add on rooms as their finances and building skills permitted.

Raquel pursued a similar strategy. When we stood on the ground between the *Dry Toilet* and the house she had built with her own hands—first collecting wood, then using mud to fill in the cracks in the wooden structure—we were in fact standing right in the middle of an additional room she had planned. Raquel's house was a growing house in the midst of a growing city.

Istanbul: *Rooftop Room*

Rooftop Room is a site-specific project real-ized for the 8th Istanbul Biennial. It consists of a tin roof constructed on top of a privately owned flat-roof house in the Kustepe suburb of Istanbul. After the exhibition closed, the family who lives in the house replaced the temporary curtain walls with permanent walls.

I was asked by curator Dan Cameron to create a project for the biennial, which had the title *Poetic Justice*. I received the invitation while in Caracas, in the spring of 2003. At the time, I was deeply involved in the *Dry Toilet* project, which Liyat Esakov and I, along with the local community, were developing in La Vega barrio. It became a matter of ethics for me that whatever project I made for Istanbul should be as meaningful as I thought the *Dry Toilet* was.

I knew from the start that I did not want to make this project in a public space.

I am aware of the fact that Europeans are unconditionally committed to public space, but this is something I have never really understood. Such dedication to the concept of public space has little to do with what these spaces actually became, that is, territories controlled by special interests. In my view, the European commitment to public space is largely symbolic and is most probably due to the reliance on the social state. One could get sentimental and look for reasons as far back as the Renaissance, when public space became a significant issue along with the democracy. A public square was intended to be egalitarian, free for everyone—consider the fact that the Swiss still vote in town squares. The notion of public space is linked with democracy and is, therefore, untouchable.

What I see in contemporary cities is not only a privatization of public space but also its erosion. In Caracas, where what little there is of the social state has been dissolving, public space is either lacking or abused. In the informal city, there is no real public space. All public space is privately negotiated, and vice versa—private space becomes public when such is needed. In the formal city, public squares have been invaded by hostile groups of people on a temporary basis, for instance, by Chavista demonstrators. Sometimes public squares end up being permanently occupied by street sellers. Temporariness, not stability, characterizes contemporary Caracas. While the Venezuelan capital might be an extreme example, the West Bank presents an even harsher scenario, in my view. There, the temporary condition is sealed behind walls while security measures are pushed to the limit. Both places are telling in the way they put an empha-sis on private space and personal security. Could they become case studies for European cities, which have been experiencing the gradual decline of public space and are consumed by private concerns? Let me give you an example from Liverpool in regard to the imposition of private security in public spaces. In the Paradise Street development in the city center, the developer plans to implement a private security pro-gram; if successful, the city may follow its example and, possibly, use private security throughout the city.

Rooftop Room, 2003
Building materials and energy and communication
infrastructure
Installed in 8th Istanbul Biennial

For *Poetic Justice*, then, I decided to create a project in private space. I focused on a family. By making a project in private space, I pointed to the ongoing process of the privatization of public space but did not waste any energy criticizing it. At the same time, I pointed to individuals—the people who make up a city. If public space thinks of citizens as a group, my project attempts to think of citizens as individuals.

My proposal was to build a temporary roof on top of a privately owned flat-roof house. I asked the Istanbul team to find a flat roof where a family planned to build another floor. I presumed that my project, though conceived as temporary, would most likely stay in place, and this eventually proved to be the case. Orton Akinci got back to me, saying that they had found a family in Kustepe, a suburb of Istanbul, who would be glad to get a temporary roof. I flew from Caracas to Istanbul. A construction worker showed us around. The roof was quite large. We decided to build a seventy-square-meter tin roof using metal construction. No plans were drawn up, and the construction was agreed on orally. The temporary intervention was approved by the city. During the biennial, blue plastic curtains were chosen to encircle the space, and it all looked quite beautiful. A plastic table and chairs—a popular style that has seemingly been around forever, were placed there. I never saw the completed *Rooftop Room* in person, but Orton sent me pictures showing how the family had subsequently upgraded the area under the constructed roof earlier this year. And so the project did turn into something permanent. I was happy to see that the plastic table and chairs were still being used.

Rooftop Room touches on several issues. This was a public project in a private space. In creating it, I diverted money from art to life. The project was not centrally located—Kustepe is an outlying suburb of Istanbul. Surprisingly, biennial organizers raised no questions either about the dislocation of the project or about the fact that a public project was being implemented in private space—visitors to the biennial could not enter the site. By making a temporary project that became permanent, I pointed to the legitimacy of so-called temporary architecture, which is, I believe, the most permanent aspect of contemporary cities. There are a few details that I especially love about this work, such as the temporary curtain walls being replaced with permanent ones and the fact that a private household was taking care of a public project.

Liverpool: *Balcony with Wind Turbine*

Balcony with Wind Turbine was installed on the fourteenth floor of the Bispham House tower block. Originally part of the movement for social housing, tower blocks are today increasingly being pulled down. Of the seventy-two social-housing high-rises once in Liverpool, only twelve remain. With the dissolution of the social state, these remaining tower blocks are being privatized. While underscoring private space and wind-generated energy, the project improves living conditions for two families.

The 3rd Liverpool Biennial had several curators. I was invited to participate by Sabine Breitwieser, director of the Generali Foundation in Vienna. My Liverpool project developed at the same time as the Istanbul project; the difference was that I first made a research visit to Liverpool before making the proposal. The biennial crew showed me around. Then unexpectedly, while talking with Paul Domela, I learned something that reminded me of the work I had done with the *Caracas Case Project*: Liverpool is a shrinking city. Both the *Caracas Case Project* and the *Shrinking Cities Project* examined the informal city, and although I knew that such towns as Detroit, Michigan, and cities in the former East Germany had declining populations, I was not aware that Liverpool and Manchester did, too. Caracas is a special case, since it comprises two forms, once considered anomalies: a growing informal city and a shrinking formal city. But from my firsthand experience I could see that Liverpool and Caracas had many things in common, though in differing intensities, such as the privatization of space, an almost absurd amount of personal security measures, the irrational treatment of space, and the collapse of large-scale systems (whether large industry or the public utilities)—the usual list of calamities that one cannot really talk about comfortably with socially hypersensitive people. Of course, Liverpool appeared to be a more balanced city than Caracas, but it was not necessarily less wild, in my view: next to London, Liverpool has the greatest number of security cameras per inhabitant in the world.

Balcony with Wind Turbine, 2004
Building materials and energy infrastructure
Installed in 3rd Liverpool Biennial, Great Britain
In collaboration with Nova Stran,
Studio for Architecture, Ljubljana

But what I remember most from my Liverpool visit is this. Although widely considered to be mismanaged, Liverpool's misguided investments and radical formal attempts to solve its problems (including the continual resettlement of residents from low-rises to high-rises and back to low-rises and, my favorite, the transformation of a slum—the city's most densely populated area—into a park) have left the city with its eyes open and its body flexible to change. Social politics is another issue. I find it strange for people to be resettled three times simply for the sake of new approaches to housing issues and yet not to really have a say about it.

As late as the 1960s, Liverpool had a slum that could have been straight out of a Charles Dickens novel. There was even open sewage there. The slum was eventually razed and the area transformed into a park. The population was resettled into tower blocks in socially subsidized housing. I was told that residents used to throw garbage out of the windows—this was something I had seen firsthand in Caracas, too, in the social housing complex of Ventitres de Enero. Of Liverpool's seventy-two tower blocks, sixty were recently torn down, with the population being resettled in bungalows. Not that residents really appreciated the change. They had formed tightly knit communities in the tower blocks and felt uneasy about the security problems they faced in the new environment.

For my project, I focused on the Bispham House tower block and its residents. My original proposal was to attach a bay window to an apartment in the high-rise and upgrade the architectural addition with a windmill, which would provide energy for the apartment. I made my decisions based on the facts on the ground. In Liverpool, modernist architecture is generally disliked and has been abandoned without regret. I thought that an addition to the flat surface of the towerblock would not be an eyesore. As for the extension of the private space, I felt it was appropriate in a city that was preparing to transform a public park into a residential gated community with big gardens. One of most important points I wanted to make was that tenants do not have to be resettled in order to improve their living conditions. The project hinted at what a small customized addition could do. The windmill was loaned by Windsave, the Glasgow-based company that developed the domestic wind unit. I imagined it would be inspiring for tenants to be independent of the municipal power grid, to be able to generate their own energy.

In the process of implementing the project, which lasted a year and a half, the bay window was transformed into a balcony. The change mirrored a new trend: balconies have suddenly become a desirable feature on residential buildings in Liverpool. As for bay windows, with which Liverpool abounds, I was reminded of the transformations they went through in contemporary Caracas. In that once-proud modernist city, bay windows used to display the interior of a home; now, they hide it. They serve to survey the outside territory from inside the house, just as in Liverpool and Manchester.

I heard from Paul Domela that the tenants where we installed the *Balcony with Wind Turbine* are happy with the enlargement of their private space, as well as with the wind-generated energy, and want to keep the balcony, which offers a fantastic view of Liverpool. Alan, the caretaker, has been volunteering to show people around who visit the tower block.

To be published in Informal Architectures, *Anthony Kiendl, ed. (Banff International Curatorial Institute, forthcoming 2005).*

MICHAEL RAKOWITZ

Opposite: *paraSITE (Bill S.)*, 1998
In use in Cambridge, Massachusetts
(CAT. 16)

Michael Rakowitz uses both

practical and metaphoric strategies to call attention to social needs. His work has had a strong (but not exclusive) emphasis on inequities within the built environment, such as the inaccessibility of affordable shelter or access to private space in most cities, or the imploded legacy of failure within America's public housing system. His hybrid art practice draws on a variety of other disciplines—design, architecture, urban planning, history, activism—and has so far included sculpture, site-specific architectural intervention, performance, and installation. In some cases his projects are designed solely for presentation within gallery spaces. Others are meant to function outside, often by offering temporary, imperfect solutions that simultaneously fill needs and bring attention to untenable situations.

In 1998 Rakowitz began collaborating with homeless men in Cambridge, Massachusetts, to design the *paraSITEs*. Apart from a few prototypes made of vinyl and nylon, these inflatable structures are made from cheap, easily available materials—tape and white, clear, or translucent plastic bags—and then inflated with waste heat vented from buildings. When deflated, each *paraSITE* folds into a small, light carrying case. When used within public spaces, they become arresting public sculptures as well as shelters from cold weather and prying eyes. Rakowitz customizes each shelter for its intended occupant, a process he relates to portraiture. He has distributed shelters in Cambridge, New York, and Baltimore. The shelter that he created for Bill Stone is presented in *Beyond Green*; Stone gave it back to Rakowitz once he no longer needed it, and it retains the stains of use in the streets. The *paraSITE Kit* (2005) presents materials needed to build one's own inflatable structure.

Rakowitz is also represented through a more recent project, *(P)LOT* (2004). Like *paraSITE*, it uses temporary, portable structures to reveal the complex ways in which public and private space are distributed in contemporary cities. Rakowitz designed an ingenious collapsible framework meant to fit standard, commercially produced car covers. When set up on the street, *(P)LOT* becomes a tent that looks like a car, creating a new kind of urban camouflage. As with the *paraSITE*, the whole system collapses into a carrying case for easy portability. As the title suggests, the piece is currently a pilot project; *(P)LOT* could eventually usurp the usual function of parking lots and metered spaces by transforming them into ersatz camping sites: *P(LOT)* users—pilots—would rent plots of city land for their own temporary, private, and independent purposes.

(P)LOT, 2004–ongoing
(2005 manifestation)
Commercially produced automobile cover and
portable framework
Installation view at Smart Museum of Art,
University of Chicago
(CAT. 17)

Interview

Michael Rakowitz: The *paraSITE* project started when I recognized that I was only getting so far in the space of architectural critique in an architecture school. Design projects needed to at least receive the criticism or the voices of the people who would be using them. When I invited that group of homeless men—Bill Stone, George Livingston, all those guys—they came to the studio and listened to me talking to them, and after I'd been talking one of them said, "So you're an architect," in a very suspicious way, and I said, "Oh, no, no, I'm an artist." They just laughed and said, "This is fine; you're not so far from being like us." Suddenly I wasn't part of the problem: as an artist, I was close to being destitute myself. So they felt some kinship and also a sense that as art, this wouldn't have to fall within the confines of being legitimate and profitable.

From there it was clear that the project would become more alive and interesting the less I was visible in it. The only part that I design on my own is the most boring but also most critical part of the *paraSITE* structure: the attachment to the building. Its symbolism is important, since it's like some weird form of architectural CPR where one edifice is giving life to another by blowing life into lungs. It also serves a key technical function by recycling the wasted energy of the city. The homeless come up with the shapes for their shelters. They give form to this symbolic method of communicating what life is like on the streets to those who don't know.

Stephanie Smith: Because of this personalized, collaborative design process, the *paraSITEs* also function as portraits (or self-portraits) of their owners. Could you talk about some of the design features that the homeless requested for their shelters and how those functioned on both symbolic and practical levels?

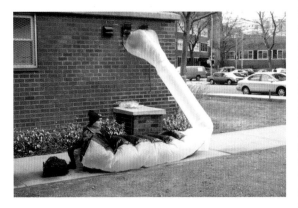

MR: In one instance back in Cambridge, I had been introduced through George Livingston and Bill Stone to Freddie Flynn. During our first conversation, Freddie, a relatively shy man, said, "Bill and George told me you'd build me anything I want." I answered, "Yes, Freddie, that's right." He looked at me intensely. "Anything?" he asked to which I again answered "Yes." What I didn't know was that Freddie was an avid science fiction fan, and he came back to me with a torn out piece of a sci-fi magazine that had a picture of Jabba the Hutt printed on it and he said, "I want to live in this!" So for the next 10 days I very enthusiastically built this sculpture/shelter of Jabba the Hutt, by far the most complicated design I've had to produce to date, but also a pleasure.

On a more pragmatic note, a December 1999 article about the project in the *New York Times* exposed a city "loophole" that one homeless man, Michael McGee, decided to address in the design process.[1] The city's "anti-tent laws" were alluded to by the spokesperson for the New York City Police Department, Detective Walter Burnes. This obscure law states that any structure, domed or otherwise, standing in excess of

1. Michael Pollak, "New York Debut for Inflatable Shelters for the Homeless," *New York Times*, December 27, 1999.

Above and opposite:
Michael McGee using his *paraSITE*

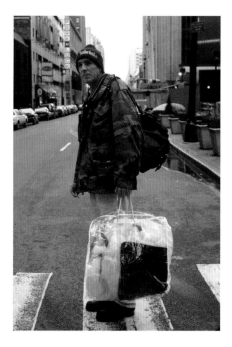

3.5 feet above the ground and capable of housing someone inside, is considered a tent, and use of the structure on city streets is considered illegal camping. Given the incidence of homelessness in New York City, these laws are clearly meant to anticipate the possibility of "tent cities" and to prevent against an appropriation of "public" space. In response to the ordinance concerning height, McGee raised the question of what would happen if his shelter were shorter than the 3.5 foot maximum, thereby challenging the defensive efforts of the city and circumventing the law.

My relinquishing of control has been a big part of a lot of the projects that I've done; I like public art that enlists the audience as vital collaborators in the production of meaning. Of course, there are times that such an open system can only lead to failure, but I think that failure is highly underrated. Artists need to reclaim this right to fail.

SS: Absolutely: there are times that you need to run with an idea and see what happens. Where do you see failure within the *paraSITE* project?

MR: Earlier, you had asked me if I categorize it as design or art. I would say it's a failing design project, because if I were a designer my responsibility would be to devise a solution. Maybe this is a problem with design practice. Maybe we should pick problems and throw more problems at them in order to create an enraged but highly valuable public dialogue about the problem. So for me, when [former New York mayor Rudy] Giuliani got angry about this project, or when he went nuts and enforced all these anti-homeless laws that, by the way, had already existed in the city's charter, he may have been doing the city a favor by agitating a dormant issue into something that created a sense of solidarity with the homeless. So, the failure of *paraSITE* as a design project may put the onus on designers to provide proposals for a longer-lasting structure to get the homeless off the streets, instead of prolonging life on the streets, which is what my project does.

SS: Have you kept in touch with these homeless men over time, and do you find they are still using your structures?

MR: A lot of them are. In New York it has been harder and harder to keep track of this, because after September 11, you don't fuck with building ventilation, so it's become harder to do this project. I'd say there's been a decrease in the number of New York homeless who want the structure, but there's been an increase in Baltimore. It's amazing how much extra space exists in that city. One of the interesting parts of the history is that several people who are no longer homeless have given back their shelters.

SS: Did they ask you to pass the shelters on to someone else?

MR: No, they understood the shelters as being their own.

SS: That makes sense since you design each structure in such close collaboration with its user.

MR: One came back from this guy named Bruce Wayne DeBose. Huge, delightful guy. He was amazing. He's so big, and the shelter is something like eleven feet long and four feet wide, and it's tall. When he gave the shelter back he didn't see it as a rite of passage, exactly, but it was no longer something he needed, and he told me to take it back, use it, show it on TV, tell his story.

SS: So you've released these works into the streets, off they go, they're personalized and active and alive, and some of them come back to you. Is it strange to then see them presented in museums?

MR: I don't have any problem with it. It's important that the shelters are presented along with the photographs so the work isn't misunderstood as performance. Proximity to this thing that clearly was used can also cause some discomfort for the audience. There have been preparators who have said, should we clean it? And I've said no, because it's important that they retain the marks of use. One of the exceptions is the piece up at Nato Thompson's show.

SS: *The Interventionists* (at MASSMoCA, 2004).

MR: Right. That one was a working sketch. I wanted to see if this thing would hold up and once I knew it would, I made one for Joe Haywood based on that prototype.

SS: So the object shown at MASSMoCA had a particular kind of life as part of your process but was never part of somebody's life on the streets.

MR: Right, it never left the studio. But it's important to be clear that I'll never produce one specifically for an exhibition. I don't want the project objectified. I don't want it to become some stupid inflatable sculpture in the middle of the white space that's going to please people. It should make people uncomfortable. Or it should at least have them leaving with some questions, you know?

SS: So, you wouldn't make a new piece for an exhibition, but there are two other options: you might show one of the functional shelters if its owner gave it back to you and gave you permission to show it, or you might show a prototype.

MR: Absolutely. The one that's in *The Interventionists* was also included in the Cooper-Hewitt Design Triennial. That's where a prototype really makes the most sense.

SS: Do you think that the dialogue that takes place within museums and galleries provides cultural capital that can then push your work further into other, more public conversations?

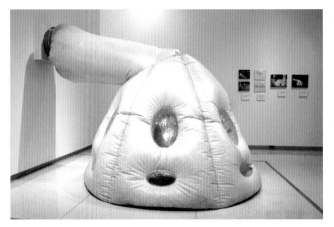

MR: Yes. The culture audience is not the primary audience, but it's important. There's a really great Hans Haacke quote about this. He was asked if he felt that his work could ever change the world, and he said he doesn't think that he can change the world, but he can change the dinner conversation. I love that. The gallery is a cultural space that's frequented by people who hold power and who are shareholders for companies like Exxon or Mobil, and they might go home and be enraged that this company that

paraSITE (Bill S.), 1998
Vinyl, nylon, and attachment hardware
Installation view at Smart Museum of Art,
University of Chicago
(CAT. 16)

they are supporting financially is participating in, say, a breach on international sanctions against South Africa, and that person might go and enact something in terms of a change. So you can connect with the ethical cogs in the machinery that you're critiquing, and that will in turn make the machinery run differently. Or, for instance, a men's organization that saw the work on display at White Columns in 2000 decided to hold a fundraiser and raised something like $30,000. They wanted to give me the money to continue to make shelters but I refused it and asked them to give it to an organization like the Coalition for the Homeless that would be capable of implementing some real change. Also, there were a couple of *New York Times* articles that came out starting in 1999. A follow-up piece noted that the evidence of the project was going to be on view at White Columns, and a lot of people who read the article ended up at White Columns. So the spaces of galleries are often thought of as being rarified and unavailable to your regular citizen, but I think if the conversation becomes a little more public, then the kinds of places where a prototype might be exhibited may be able to do something that contributes to useful debate.

Getting back to the question of failure: a lot of my projects will enlist function but also failure. The *Minaret* project (2001), for instance, deals with the absence of the call to prayer in the United States in cities where there is a significant Muslim presence. It's meant to raise awareness. You're hearing an aural presence and it makes you aware of the absence. It's also semicomedic in a Jacques Tati way, since I stand on the top of a building with the most powerful civilian-issue megaphone that you can get, which is not incredibly powerful, and broadcast the call to prayer from this kitschy miniature alarm clock that many Muslims in the U.S. use.

SS: There's a way that the minaret alarm clock serves a similar purpose to your shelters, right? It's a temporary, inadequate solution to a larger social need.

MR: Yes. Ultimately the project is set up to fail. I would love for *Minaret* to disappear because someone builds a minaret in the middle of the city that connotes that there are these important people amongst us from a culture that's been vilified and misunderstood and still undergoes the worst kind of racist scrutiny. We're living this history, and I'd like to know that in 30 years we'll all be embarrassed about it. That's optimistic, but it's related to my desire for *paraSITE*. It would be great if that project were never done again because somebody came up with some amazing new affordable housing initiative and found a new way of sustaining human life in the city. Both projects are ways of making the invisible visible.

SS: That works in both actual and metaphoric ways in *paraSITE*: you had initially proposed using black plastic for the shelters, but the homeless men with whom you were collaborating saw that as dangerous both since they wouldn't be able to see out of the shelters and also wouldn't be visible to passersby.

MR: It was great for me to hear that. It was a practical thing but it was also symbolic, so we were speaking the same poetic language. They didn't have any privacy issues but they had security issues—they wanted to see potential attackers, and they also wanted to be seen. That's the kind of thing that you can never figure out for yourself when you're just designing in your studio. A lot of my projects have taken that trajectory: presenting a platform and then letting people enter that platform.

March and June 2005

Michael Rakowitz thanks Kai Bailey, Melissa Daum,
Michelle Longway, and Sarah Sevier

FRANCES WHITEHEAD

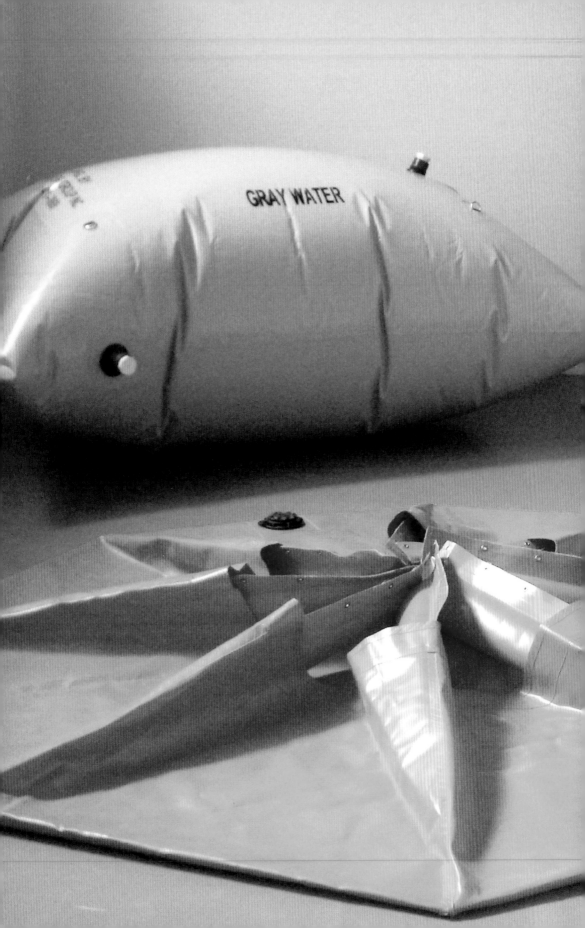

Frances Whitehead delves

into the intersection of nature and culture in her work. Her earlier projects incorporated computer-based visualization tools to make models of organic forms such as viruses, which she then adapted as sculpture. Recently, she has looked more specifically at the impact of human activity on watersheds, exploring creative systems of remediation, visualizations of future urban development, and sculptural means to depict statistical information.

Primary Plus focuses on the relationship between design and disaster. For this project, Whitehead uses the classic strategy of bringing found objects into the gallery space, relying on the museum's authority as a framing device to allow viewers to reconsider objects that have other functions in the so-called real world. In this case, she offers a selection of large, commercially produced, inflatable objects that are designed to collapse and fold into small packages in order to be transported and reused in response to environmental and social disasters. These include bladders to hold drinking water for humanitarian needs, tanks to hold gray water for firefighting and other needs, and "booms" to contain toxic spills. Whitehead has chosen a selection of objects that can be edited and arranged in each exhibition venue to form an installation that suits the available space. At the close of the exhibition, Whitehead will return the inflatables to the company that produced them so they can be reused as product samples or in the field.

Whitehead wants to call attention to the many-layered ambiguities of these containers. They are sturdy, reusable, and made to help staunch environmental problems, and so fit some aspects of sustainable design, but they are also emblematic of a culture that offers surface solutions rather than seeking to address root causes. In addition, Whitehead chose the examples presented in *Beyond Green* in part for their visual appeal. With their strong colors and simple forms the sculptures look at home in the gallery. Once placed in that rarefied arena they strongly recall the industrial aesthetic of minimalism, and thus emphasize the tension between the social and the formal aspects of art.

Primary Plus, 2005 (detail)
Variable selection of commercially produced inflatable objects and
their cases
Installation view at Smart Museum of Art, University of Chicago
(CAT. 19)

Interview

SS: How did you first get interested in sustainable practices?

FW: When I first moved to Chicago, I started a garden on the side lot next to my house. I'd never had a garden, never wanted one. Like many urban people who react to the absence of nature in the city, I became very involved with gardening and eventually it became part of my work, an extension of my prior interests in art and science. Working in the garden helped me become more knowledgeable and more tuned in to natural systems and environmental issues. I had thought I was just going to make a flower garden, but first I had to deal with the soil, which was full of debris. That got me thinking about reclamation. Many years have passed since then, and through the School of the Art Institute of Chicago, where I teach, I have had the opportunity to spend time with some sustainable design theorists and was exposed to that discourse on a philosophical level.

SS: Could you talk more specifically about how this affected your practice?

FW: Five years ago I realized I had been looking backward, lamenting a lost purity of nature, paradise lost. This was getting us nowhere; I needed to become more proactive. I became more politicized in general, and that led to a radical change in my work from a more romantic excavation of historical and botanical subjects to a proactive and politicized body of work. I also looked at my own life and realized that I was living a modernist art lifestyle in a big cavernous place with more space than I need. So my husband and I are building a smaller, leaner home and studio that incorporates principles of sustainable design. Actually, it was through searching the web for cistern liners for the house that I found the inflatable objects that will be presented in *Beyond Green*; some of the same companies that make these objects also make the cistern liners, which we need for water reclamation at our new home.

SS: Could you describe these objects and your project?

FW: The project, *Primary Plus*, presents examples of a type of monumental, collapsible, industrially produced object that is currently in worldwide use. These brightly colored geometric forms are the embodiment of a new global emergency and disaster response culture and are used by military, corporate, survivalist, and humanitarian organizations for spill containment, fire fighting, and temporary storage of liquids. They're color-coded for the end-user: typically blue or white for potable water, black for nonpotable water or fuel, tan or khaki for jet fuel and military applications, yellow for high visibility, and orange, the most inexpensive and therefore ubiquitous color, for gray water and disposable contents. I'm bringing a selection of these found objects into the museum where they function in relation to a minimalist sculptural aesthetic, as well as to their intended use in disaster response. Ambivalence is a key term for this project. Things operate at a juncture between understanding them as part of an art-historical iconography and seeing them as functional objects. This slippage between what something is and what it appears to be is very extreme in this case. That interests me. I also find their scale compelling, because it begins to hint at the magnitude of the environmental issues facing us. I'm also interested in places where Enlightenment categories of material culture dissolve and art blends into anonymous design.

SS: Let's talk about the objects in their first lives as functional items. Do you think they're examples of effective, sustainable design?

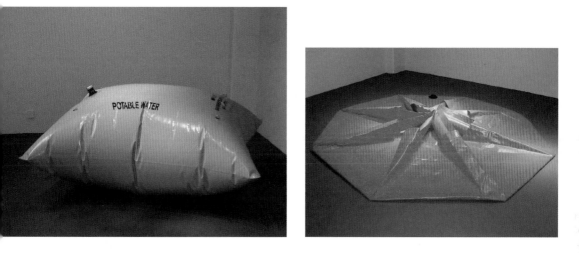

FW: This is another ambivalence within the project. Toxic spills and industrial "acci-dents" clearly need remediation, and the ingenious devices designed for this purpose —the objects I'm showing—do an environmental service by helping to sustain beaches and wetlands. However, do sophisticated remediation strategies perpetuate unsustain-able practices such as shipping crude oil across the oceans? Does the automobile inscribe the design of these inflatable devices? Are they perhaps both reactionary and sustainable? If so, what are they sustaining? The status of the inflatable tanks used to supply potable water for humanitarian relief is just as ambiguous. In refugee camps and areas of unexpected drought, these devices are a godsend, allowing fast, inexpensive, efficient delivery (by aircraft drops) of drinking water. In the future, will these devices become as familiar as the gas tank? Fresh water, already a crisis in many parts of the world, represents a new global economy built on a strategy of shifting resources that is transient, nomadic, and extra-geographic. Perhaps to see this as dire is nostalgic, sentimental, or provincial. As design and environmental philosophy have moved beyond ecological or green design into the more complex model of sustainability, one central tenet is the need to design proactive systems on the front end, moving out of a reac-tive mode. Further, sustainability might only be achieved by recognizing the impact of "inscriptive" design, design that produces situations and behaviors that go on to "design" other situations and behaviors that in turn "design" the designers. Sustainable design theorist Tony Fry calls this "ontological circling."[1]

SS: You've borrowed all of these inflatable objects from the companies that make them. Could you describe the responses when you proposed this project?

FW: The owner of one company, Dr. Fakhimi of Texas Boom, Inc., is an academic who started making these products after working for years as a chemical engineer. Referring primarily to oil spills, he told me, "Engineers helped create this mess and we needed to figure out how to clean it up." When I told him the nature of the exhibit, he said, "They should give you a medal for raising these issues." Clearly he was receptive; he got the project. He did not seem surprised that I see these objects sculpturally and appreciate their high level of craft, which of course is necessary for them to function.

Above and right: *Primary Plus*, 2005 (detail)
(CAT. 19)

1 . Tony Fry, *Remakings: Ecology, Design, Philosophy*
(Sydney: Envirobook, 1994).

SS: Let's talk about their function within the museum.

FW: It exposes them to the museum as a viewing space, as a place where ideas are presented, aestheticized, and consumed. Aesthetic issues aren't in play when an inflatable water tank is being used to fight a fire. These objects need the museum to raise these questions, because when they are out in the world you never really "see" them.

SS: Moving these things into the gallery space is a classic maneuver. It brings them into a "wrong" context that allows them to be perceived aesthetically, as sexy, tactile, well-made objects. It also provides a little breathing room so one can think about them not only in relation to art-historical categories like "minimal sculpture" and "found object," but also in relation to their actual use. In the gallery, they can raise questions about complex issues of sustainability and design in a way that wouldn't be possible when they are used for disaster response.

FW: Yes. I don't think of this as sculpture. I think of them as part of a conceptual project, as props that elucidate a conceptual framework. I really don't think of these as sculpture, because that gets into a peripheral inquiry about authorship, craft, and uniqueness. Of course the minimalist sculptors in the 1960s opened this door; they had other people make their work and established that the artist's hand and touch did not have to exist in the work, which was already hinted at by numerous other works—Duchamp's art, collage, etc. The minimalists made this really clear. I just walked through the door they opened by appropriating these inflatables into my own work.

SS: To me, what you are doing seems more akin to a readymade: you're recontextualizing something that already exists. These make me think more of Duchamp's *Trébuchet* (1917), in which he placed a hat rack on the floor. The simple act of displacement trips you up, traps your attention, and opens up other ways of experiencing this thing.

FW: Yes, but they still relate more to minimalism formally. As an artist, although maybe not so much for a general visitor, these objects are familiar; they evoke the forms of minimal sculpture so they seem familiar and right in the gallery. The minimalists took their language from industry, and I am putting it back. We can skip the stage of making work

Primary Plus, 2005 (detail)
(CAT. 19)

in an industrial manner and just go get the industrial thing. I did make some aesthetic choices; I paid attention to things like size, shape, and color when I requested these objects. Not just any inflatable would work well in this context. I was playing up their primary-ness, their primary structure-ness. I wanted to include a variety of objects not just for the sake of the taxonomy but also to get the most formal mileage that I could out of each one.

SS: Could you talk about the title of the piece? *Primary Plus* **relates these industrial objects to art, since** *Primary Structures* **(1966) was the title of the first museum show of minimalism. But what else did you want to evoke?**

FW: I am definitely thinking about them as primary structures. Also their colors aren't primary but they're close, they're crayon colors. They're primal, too.

SS: And by primal you also mean their use in the world, dealing with our basic needs for water and safety?

FW: Yes.

SS: It's interesting to think about another tension or ambiguity, this time between objects that meet a primal need and those that, when presented as art, have a kind of playfulness—here as a side effect of being inflatable.

FW: Yes. When they're inflated they appear cheerful and comic, and depending on how they are laying around the space, they can look very humorous.

SS: Sitting here in your studio, I'm looking at a black, nonpotable water tank. It's partly the angle at which I'm viewing it, but there's a certain menace to it. The ways these are presented will definitely have an impact on the attitudes that people attach to them.

FW: Absolutely. Their position in space is really important, because it establishes not only the formal configuration, but also the mood. Proximity is also significant—the degree to which the public is allowed to walk right up to them and begin to use their bodies consciously or unconsciously to measure what size they truly are.

SS: These configurations will change as the show travels: each venue will have the opportunity to choose from a "menu" of inflatables that you've provided, to create arrangements that suit their spaces.

FW: As I said, I think configuration is important. You need at least two, since they inform each other visually. A configuration might also include stacks of the uninflated folded ones or their carrying cases. When they first arrived, they were each packaged in their own individual carrying case with nylon rope and grommets and plastic ties. They're portable; they stack; they go where they need to go for emergency response.

SS: We've talked about reasons why these forms are visually satisfying and how they can connect back to different moments in art history and to things that are familiar from everyday experience, but the visual connections fall flat unless the objects can trigger reflection about these other networks you mention.

FW: It is hard for me to think about that aspect of my work. Yet people point it out to me, and at moments like this, as I try to unpack something with assistance, I start to see it—many of my works are about systems but are manifest as objects or things. The way material culture operates, the knowledge objects hold, and the cultural roles that they play as embodiments of systems, are not very well understood. It's hard to talk about, but that's really at the heart of my interest in sculpture.

June 2005

WOCHEN KLAUSUR

Opposite: WochenKlausur banner installed
outside their temporary office at Midway
Studios, University of Chicago, 2005

Based in Vienna, this group

of activist artists has been working together since 1993. They leverage the resources of art world institutions—museums, for example—to devise concrete means of addressing specific social problems. Their projects always involve a residency of up to eight weeks; during that time they bring diverse groups of people together to develop solutions to the problem under consideration. Their name translates as "Weeks of Closure" and describes the intense, productive time of the residency. WochenKlausur creates small-scale but long-term solutions; in their words, "artistic creativity is no longer seen as a formal act but as an intervention into society."

Recently WochenKlausur has established several small-scale initiatives to upcycle materials into useful new objects. (Upcycling is a process in which waste materials are put to new uses without being broken down into component parts; for example, transforming stoplight glass into red, yellow, or green vases.) Their project for *Beyond Green*—their first residency in the United States—builds on this prior work. While in Chicago for three weeks during the summer of 2005, WochenKlausur members worked closely with a group of University of Chicago students and other volunteers to research and implement an initiative to upcycle byproducts of museum exhibitions, theatrical productions, and other waste materials. During the residency, they set up a temporary studio/office on campus in Midway Studios, the historic building that houses the Department of Visual Arts. From that home base, they compiled a network of potential collaborators and conducted a test upcycling effort: they designed, built, and delivered furniture to a Chicago women's shelter.

WochenKlausur's projects are unabashedly instrumental, and they work to develop solutions that can continue without their involvement after the residency ends. In Chicago they started a new entity called Material Exchange, which will continue the work of linking waste materials, designers and design students, and people in need. Four students from the University of Chicago and the School of the Art Institute of Chicago who collaborated with WochenKlausur during their residency have taken on the leadership of this new organization and have already begun work on several upcycling projects, including a trial partnership with a Chicago design school and the production of the furniture used in *Beyond Green*. Thus the conversations and collaborations that comprise the heart of every WochenKlausur residency are already generating lasting, sustainable networks and alliances among the participants. Material Exchange is the primary result of their work, but the project is also represented within the exhibition through drawings, a documentary DVD, and the upcycled exhibition furniture.

Intervention to Upcycle Waste and Museum Byproducts, 2005 (detail)
Single channel video with sound; two framed drawings (ink on
paper); two inkjet prints; four benches, one table, and one shelf made
from salvaged materials (wood, plexiglas, and moving blankets)
Installation view at Smart Museum of Art, University of Chicago
(CAT. 20)

Statement

WochenKlausur was formed in 1993, when Wolfgang Zinggl invited eight artists to work with him to solve a localized problem during the exhibition *11 Wochen in Klausur* at the Secession (an exhibition hall for contemporary art in Vienna). During the span of that exhibition, the group developed a small but concrete measure to improve conditions for homeless people in Vienna by making medical care available to them through a mobile clinic. Since 1993, more than 600 homeless people per month have received free medical treatment at this clinic. An invitation from the Zurich Shedhalle followed in 1994. There, WochenKlausur worked with members of the government and social service groups to establish a hotel for drug-addicted women. Invitations from art institutions in Austria, Germany, Italy, Japan, Sweden, and the Netherlands followed. A total of twenty projects have been successfully conducted in recent years by teams that have involved a total of more than fifty artists.

WochenKlausur often faces questions about why our projects should be considered "art." In what many people understand to be traditional art, a great diversity of materials are formed and manipulated. Marble, canvas, pigments, and other materials have been points of departure for many kinds of creations, and through these media, the artist's imagination takes tangible shape. In activist art, sociopolitical relationships take the place of those material substances. As with marble or the painting surface, this substance is not infinitely malleable. In order to transform existing circumstances, the limits of variability must be recognized just as they must be in traditional art. This means that the hurdle—the envisioned transformation—must be carefully set: it must be realistic but also high enough that one can speak of a noticeable change. The goal is to design a recognizable and sensible change and then accomplish it. For example, an artist could take it upon herself to get a one-way traffic regulation for her street repealed because she recognizes the senselessness of the regulation. She would do everything possible to realize her plan, just as the Baroque master made an effort to realize his plan for a ceiling fresco in a cathedral regardless of whether he personally put his hand to the task or not.

We are often asked, "Why must a sociopolitical intervention be art? Can it not simply remain what it is?" We answer with our own questions. Why must Joseph Beuys's *Fat Chair* (1964) be art? Why are Duane Hanson's hyper-realistic polyester figures categorized as art while Madame Tussauds' wax figures are not? Why must a black square be art if it could just as well have been painted by a house painter as a color sample? Of course, a sociopolitical process can also have nothing to do with art. All around the world, public projects and initiatives are successfully completed without even the slightest consideration as art. For example, Gregor Hilvary, a priest who ran a shelter out of his own home in Hollabrunn, Austria, thought out an ingenious rotation system in order to offer more refugees beds than the law allowed, thus protecting them from deportation. He didn't receive any art professorship for his achievement. Why art, then?

First, with every successful project that is recognized as art, intervention in existing social circumstances increases in significance. The word "social" is then used more positively again. Just as art can make certain "revolting" materials suddenly more appealing, it can also decrease the nimbus of pathos and the presumption of a "do-gooder syndrome" that often surrounds social efforts.

Second, the mythos of art can be useful when one attempts to realize an intervention in the political field. For example, in 1989 the artist Patricia L. A. Paris designed an installation to light a long, dark underground passage in Whitechapel, London. This meeting point for criminals was to be lit with four floodlights, brighter than the light of day; the plan won a design competition but was never executed. Shortly before her project was to be set up, lighting was installed in the passageway by the community itself, which also took the opportunity to clean up trash and pigeon corpses. Paris was infuriated. Her planned floodlights had lost their purpose, so she withdrew the project. And yet it had been her idea to improve the passageway's lighting. Her intention was realized, even though she had contributed nothing more than her plans. With the help of her art, the authorities had been compelled to take action. As an average citizen she might also have achieved the same thing, but she would have had to place an official request for better lighting, like many others before her, with forms, waiting lists, and fees. Months later she would have received a letter that informed her that the current circumstances made it impossible to fulfill her request.

Third, the media reports more about the dullest cultural events than about the most exciting social work. Through newspapers, radio, and television coverage, pressure can be put on decision makers. For instance, the news media helped WochenKlausur in its first project (the mobile medical clinic for the homeless). The moderator of a Viennese radio program called a member of city government live on the air and asked her why the government would not subsidize the salary of a doctor for the clinic, especially when such a measure was in the spirit of the Social Democrats' policies, and moreover, when WochenKlausur had already made all the arrangements necessary to set up the clinic.

WochenKlausur's calendar in their office at
Midway Studios, University of Chicago, 2005

WochenKlausur members Martina Reuter, Claudia
Eipeldauer, and Wolfgang Zinggl in their office at
Midway Studios, University of Chicago, 2005

Fourth, experience from the completed projects shows that in many fields an unorthodox approach opens doors and offers solutions that would not have been recognized in conventional modes of thinking, such as those of science, social work, or ecology. During a project to improve the sense of well-being in a Viennese secondary school classroom, WochenKlausur simply ignored the Austrian standards for school construction because they were completely inappropriate in meeting the pupils' needs. This is an advantage for artists, since experts in other fields must conform to the existing guidelines in order to avoid potential difficulties in their professions, even when the guidelines are clearly preposterous.

WochenKlausur does not claim that artists should necessarily have better ideas and problem-solving strategies than other groups. But there are many reasons why such interventions should be carried out by artists—as well as by all other people—if they are efficient. When obvious deficiencies in the social sphere await action, and when their solution does not require years of training or special experience, one has a responsibility to participate in finding solutions outside the framework of official directives and organizational structures. Clearly, when these activities are carried out by artists at the invitation of art institutions and are recognized by a community as art, then they are art.

Chicago Project for *Beyond Green*

Responding to this exhibition's title and tenor, WochenKlausur, which mostly addresses social problems, decided to combine both a social and an ecological approach within its project for *Beyond Green*.

Wolfgang Zinggl preparing upcycled furniture for Deborah's Place (left), and the completed furniture (right) at Midway Studios, University of Chicago, 2005

For every stage set or exhibition design many objects have to be built for temporary use. Therefore an abundance of material like wooden boards, display cases, glass panels, fabrics, and other odds and ends from past shows at museums and theaters accumulates and is generally disposed of after use. Materials that one person considers waste may be the raw materials of a new product for another. For this reason, WochenKlausur has set itself to the task of building a chain between institutions such as theaters and museums that have useable leftover material; social institutions that know what kind of necessities like furniture, interior fittings, and so on are required by people in need; and design schools and institutions that could create ways to upcycle the surplus material in order to produce the required utilitarian objects.

In Chicago, WochenKlausur members worked with University of Chicago students and volunteers to initiate an organization to create this chain. After meetings with a number of social organizations, we discovered a huge demand for furniture and interior fittings for entities such as homeless shelters and clothing pantries. We gathered lists of leftover materials, starting with waste from the Smart Museum, and extended out to involve other Chicago-area museums, theaters, and like institutions that are willing to make their surplus available. Design schools and departments have agreed to join the network and will help transform the materials into new things.

Alongside the organizational work, WochenKlausur has produced an upcycling example. Deborah's Place, a homeless shelter for women, asked for outdoor furniture such as tables and seats for their courtyard. Cable drums, wooden boards, hoses, tripods, and other discarded materials were gathered and brought to the workshop at Midway Studios. There, we upcycled the material according to the expressed need, prepared it for outdoor use, and delivered it to the shelter. WochenKlausur also developed another set of furniture designs, which Smart Museum staff built as prototypes to travel with the exhibition along with documentation of the residency.

To carry on this work we and our collaborators founded a new, non-profit organization named Material Exchange. Material Exchange is now led by team of students from the art departments of University of Chicago and the School of the Art Institute of Chicago. They are continuing WochenKlausur's project by developing Material Exchange into a sustainable organization; they will plan and establish the proper system to coordinate this new network of institutions, organizations, and design schools.

August 2005

WochenKlausur thanks project participants Alta Buden, Rosalind Carnes, Samantha Chang, David Hernandes-Casas, and Aurelia Collados de Selva; Material Exchange members Sara Black, Qaid Hassam, and Charles McKissack Hasrick; videographer Irena Knezevic; and all of those who lent their time and expertise to the development of the project.

The Material Exchange Web site

ANDREA ZITTEL

Opposite: *Raugh Shelving Unit with Fiber Form Bowls and Found Objects from A-Z West*, 2005
Laminated ACX plywood, cardboard boxes with burlap and plaster, fiber form bowls, and found objects
(CAT. 22)

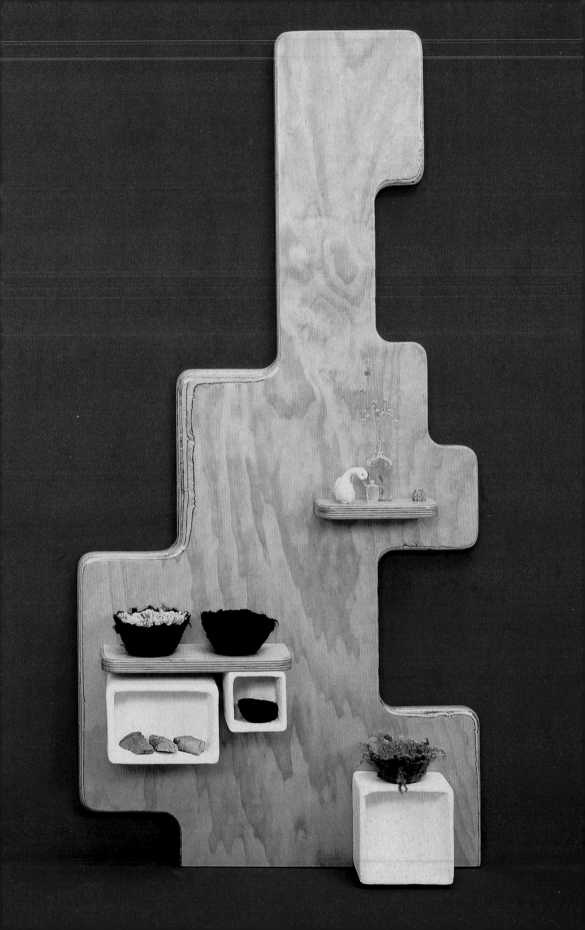

Andrea Zittel has been

working at the intersection of design and art since the early 1990s. Her art initially took the form of appealing, utilitarian fashion and furniture, a project that started as a strategy of personal self-sufficiency and developed into a coherent body of material that she presents under the "brand name" A-Z (*A-Z Uniforms*, for example). In the late 1990s, Zittel moved from New York to a remote high desert site in California in order to pursue more focused explorations of ideas and materials. She describes her home there, A-Z West, as "an institute of investigative living" and notes that the "A-Z enterprise encompasses all aspects of day-to-day living. Home furniture, clothing, food all become the sites of investigation in an ongoing endeavor to better understand human nature and the social construction of needs."

This multipart installation samples Zittel's larger, ongoing project, *A-Z Advanced Technologies*. In these simultaneously philosophical and practical investigations, Zittel has devised ways to simplify daily living, which for her includes her work as an artist. She has developed processes to make art from simple methods, using easily available renewable or waste materials such as wood, cotton, wool, and even junk mail. In the installation presented in *Beyond Green*, the artist used commercially produced carpet and paint as an abstract backdrop for several discrete elements: a billboard prototype; one of her trademark plywood shelves adorned with hand-felted bowls and found objects; and an abstract shape that she crocheted by hand.

The latter plays with art history to subtly underscore Zittel's utopian aspirations for a new mode of daily living. Through its dramatic shape and its title—*Forward Motion*—this irregular piece of handicraft recalls the work of revolutionary Russian painters and designers who tried to enact radical new ways of living and working almost a century ago. In such works, Zittel embraces the speculative uses of art: in a recent interview she noted, "I am not a designer— designers have a social responsibility to provide solutions. Art is more about asking questions."

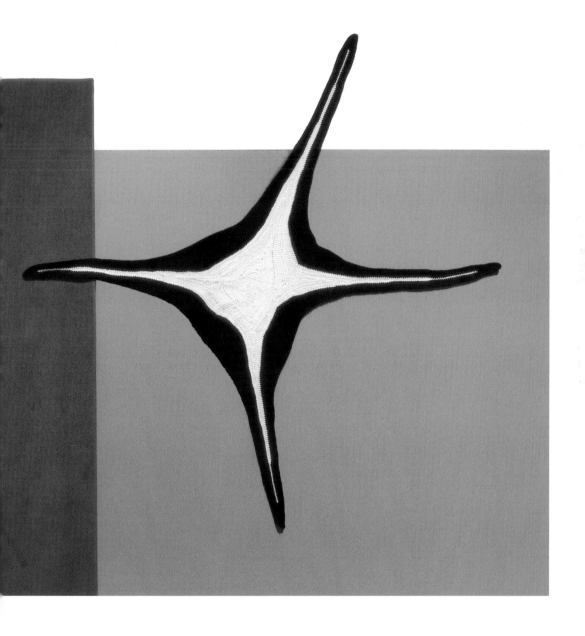

*Single Strand Shapes: Forward Motion
(Big Black and White X)*, 2005
Crocheted sheep and llama wool
(CAT. 23)

Installation view at Smart Museum of Art,
University of Chicago
(CATS. 21–23)

Statement

A-Z West is located on 25 acres in the California high desert next to Joshua Tree National Park. Since fall 2000 the cabin and grounds have been undergoing a conversion into our all-new testing grounds for our "A-Z designs for living." This desert region originally appealed to us because it seemed that one could do anything here—which we are finding out isn't exactly true! It is also the historical site of the five-acre Homestead Act. In the 1940s and 1950s legislation gave people five acres of land for free if they could improve it by building a minimal structure. The result is a seemingly infinite grid system of dirt roads that cuts up a very beautiful desert region. In the middle of each perfect square of land is a tiny shack—most of them long since abandoned. The area and its history represent a very poignant clash of human idealism, the harshness of the desert climate, and the vast distances it places between people.

Initially, the primary focus at A-Z West was on production and how to develop new materials and new kinds of fabrication techniques. After working outdoors in 110-degree temperatures and contending with seemingly infinite budget problems, I believed that there must be a way to make interesting and significant art for less money, and less physical toll. This led to the search for a new technology: *A-Z Advanced Technologies*. Looking for the most plentiful and least costly resource available, I decided to find a way to use my paper waste as a building material. Stacks of old newspapers, magazines, mail order catalogs, and office debris were almost overwhelming in their volume,and were ordinarily something that I had to haul to the local dump. To turn paper into a moldable material it is first shredded and pulped. Then it is packed into a series of plastic molds, which slide into a grid of steel frames so that the pulp can dry outdoors in the hot sun. The installation of the Regenerating Field consists of a grid of 25 trays that spills down the hill in front of the A-Z West Homestead. The work references both the aesthetics of earthwork installations (like the *Lightning Fields* by Walter de Maria) and the industrialized format of modern day agriculture.

Dried paper pulp is lightweight, incredibly strong, and can be molded into shapes that look like fiberglass, concrete, or even travertine stone. And of course the dry, moistureless desert, where A-Z West is sited, is perhaps the most perfect place for this type of new technology. Although eventually I plan to use my process to build furniture and larger structures, the initial attempt has been to create an attractive, durable wall panel. Something that could camouflage bad walls and add softness and texture to a room. A little like the phenomena of wood paneling of the 1960s and 1970s, but without all of the connotations of that era.

Since 1991 the technical and conceptual evolution of the *A-Z Uniforms Series* has been gravitating toward an increasingly direct way of making

These things I know for sure:

Inventing categories creates an illusion that there is an overriding rationale in the way that the world works.

#1. It is a human trait to want to organize things into categories.

my own garments. After finally reducing the tools of production to simply crocheting the strands of yarn directly off of my fingers, I began to consider the material that I was using. What if I could trace the strand of yarn back to its original form as fiber? Now I am finally beginning to make the most direct form of clothing possible by hand, "felting" wool directly into the shape of a garment and thereby inventing my own ways to make shirts and dresses. Because the clothing is made as one piece there are no seams involved, and when it is finished I use a safety pin to connect the two sides so that it will stay on! I have encapsulated this body of work under the heading *AZ Advanced Technologies*, which plays off the way that something can be both incredibly primitive and quite sophisticated at the same time.

2003

Prototype for Billboard at A-Z West:
"These Things I Know For Sure #1," 2005
Flashe and polyurethane varnish on
birch plywood
(CAT. 21)

Dimensions are in inches (and centimeters); for two-dimensional works of art, height precedes width; for three-dimensional works, height precedes width precedes depth.

Allora & Calzadilla

1. *Returning a Sound*, 2004
Single channel video projection with sound
5 minutes, 41 seconds
Collection of the artists; courtesy Galerie Chantal Crousel, Paris

2. *Under Discussion*, 2004–05
Single channel video projection with sound
6 minutes, 3 seconds
Collection of the artists; courtesy Galerie Chantal Crousel, Paris, and Lisson Gallery, London

Free Soil

3. *F.R.U.I.T*, 2005
Interactive installation with wood, cloth awning, wood boxes, styrofoam, paper wrappers, computer equipment, and three Iris prints
Fruit stand: 7 ft. 6½ in. x 7 ft. 8 in. x 6 ft. 6 in. (2.3 x 2.4 x 2 m); computer terminal: 40½ x 23½ x 17¾ in. (102.9 x 59.7 x 45 cm); Iris prints 16 x 20 in. (40.6 x 50.8 cm) each
Collection of the artists
Commission, Smart Museum of Art, University of Chicago

JAM

4. *Jump Off*, 2005
Mixed media installation with hand-made cloth and leather bags, flexible solar panels, flat screen monitor, DVD player, cell phone, and electrical circuitry; Flash animation by Arthur Jones
Installation dimensions variable; approx. 60 x 96 x 96 in.
(152.4 x 243.8 x 243.8 cm)
Collection of the artists
Commission, Smart Museum of Art, University of Chicago

Learning Group

5. *Collected Material Dwelling, Model 1:1*, 2005
Mixed media installation including recycled cardboard, recycled bottles, fabric, rope, metal, plastic container, and hose
Overall installation dimensions: approx. 8 ft. 4 in. (2.5 m) high x 15 ft. 9½ in. (4.8. m) diam.; dwelling: 7 ft. 10 in. (2.2 m) high x 6 ft. 10 in. (2m) diam.
Collection of the artists
Commission, Smart Museum of Art, University of Chicago

6. *Collecting and Connecting Systems Drawings*, 2005
Six inkjet prints
8 x 11 in. (20.3 x 27.9 cm) each
Collection of the artists

7. *Learning Model: Mushroom Garden*, 2005
Papier-mâché and acrylic paint
21¾ x 29¾ x 15¾ in. (55.2 x 75.6 x 40 cm)
Collection of the artists

8. *Learning Poster #001 > Collecting System*, 2005
Inkjet print
23½ x 33¼ in. (59.7 x 84.4 cm)
Collection of the artists

9. *Learning Poster #002 > Connecting System*, 2005
Inkjet print
23½ x 33¼ in. (59.7 x 84.4 cm)
Collection of the artists

10. *Learning Poster #003 > Collecting System*, 2005
Inkjet print
23½ x 33¼ in. (59.7 x 84.4 cm)
Collection of the artists

Brennan McGaffey
in collaboration with
Temporary Services

11. *Audio Relay*, 2002–ongoing
(2005 manifestation)
Painted wood case, audio transmitter,
antenna, solar panels, electric cables,
CD player, CDs, speakers, and stickers
Installation dimensions:
10 x 8 x 8 ft. (3 x 2.4 x 2.4 m)
Collection of the artist

Nils Norman

12. *Ideal City, Research/Play Sector,
Chicago*, 2005
Printed vinyl mural
9 ft. 6 in. x 30 ft. (2.9 x 9 m)
Galerie Christian Nagel, Berlin

People Powered

13. *Transport I: Loop and Soil Starter*,
2005
Wall installation with recycled paint
and paint swatches; wood case with
stool, computer equipment, metal
cans, sample kits made of biodegrad-
able plastic encasing inkjet prints,
paint sticks, paper, soil, and organza
Display case, closed: 64 x 45 x 20 in.
(162.6 x 114.3 x 50.8 cm); installation
dimensions variable
Collection of the artist
Commission, Smart Museum of Art,
University of Chicago

Dan Peterman
A variant of this work is presented by tour
venues following the Smart Museum.

14. *Excerpts from the Universal Lab
(travel pod #1, #2, and #3)*, 2005
Assorted materials in plexiglas
spheres on wheeled metal supports
Spheres with supports: $43\frac{1}{2}$ x $31\frac{3}{4}$
x $31\frac{3}{4}$ in. (110.5 x 80.6 x 80.6 cm);
45 x $31\frac{3}{4}$ x $31\frac{3}{4}$ in. (114.3 x 80.6 x
80.6 cm); 49 x $31\frac{3}{4}$ x $31\frac{3}{4}$ in.
(124.5 x 80.6 x 80.6 cm); installation
dimensions variable
Collection of the artist
Commission, Smart Museum of Art,
University of Chicago

Marjetica Potrč

15. *A Hippo Roller for Our Rural Times*,
2005
Utilitarian plastic and metal object,
and printed drawing (inkjet print)
Object: 47 $\frac{1}{4}$ x 27 $\frac{1}{2}$ x 19 $\frac{3}{4}$ in.
(120.7 x 69.9 x 50 cm); drawing:
61 x 33 $\frac{1}{2}$ in. (154.9 x 85 cm)
Collection of the artist; courtesy Max
Protetch Gallery, New York

Michael Rakowitz

16. *paraSITE (Bill S.)*, 1998
Vinyl, nylon, and attachment hardware
60 x 48 x 116 in.
(152.4 x 121.9 x 294.6 cm)
Collection of the artist; courtesy
Lombard-Freid Projects, New York

17. *(P)LOT*, 2004–ongoing
(2005 manifestation)
Commercially produced automobile
cover and portable framework
48 x 68 x 150 in. (121.9 x 172.7 x 381 cm)
Collection of the artist; courtesy
Lombard-Freid Projects, New York.
Designed and constructed with Kai
Bailey with additional assistance from
Melissa Daum, Michelle Longway, and
Sarah Sevier

18. *paraSITE Kit*, 2005
Kit of parts comprised of boxes of
plastic bags, rolls of clear packing
tape, and scissors, on shelf
Shelf component: H. variable;
36 x 11$\frac{3}{4}$ in. (91.4 x 29.8 cm)
Collection of the artist; courtesy
Lombard-Freid Projects, New York

Frances Whitehead

19. *Primary Plus*, 2005
Variable selection of commercially
produced inflatable objects and their
cases
Installation dimensions variable: Min.
approx. 48 x 74 x 82 in. (121.9 x 187.9
x 208.3 cm); max. approx. 96 x 420 x
186 in. (243.8 x 1066 x 472.4 cm)
Courtesy of the artist with special
assistance from Texas Boom, Inc.

WochenKlausur

20. *Intervention to Upcycle Waste and Museum Byproducts*, 2005
Single channel video with sound; two framed drawings (ink on paper); two inkjet prints; four benches, one table, and one shelf made from salvaged materials (wood, plexiglas, and moving blankets)
Installation dimensions variable; two drawings: 8 1/2 x 11 in. (21.6 x 27.9 cm) each; two prints: 11 x 8 1/2 in. (27.9 x 21.6 cm) each; benches: 18 1/4 x 48 x 11 1/2 in. (46.4 x 121.9 x 29.2 cm); table: 18 x 30 x 30 in. (45.7 x 76.2 x 76.2 cm); shelf: 7 1/2 x 72 x 12 1/2 in. (19.1 x 182.9 x 31.8 cm)
Collection of the artists
Furniture designed and built by John Preus for Material Exchange; video by Irena J. Knezevic
Commission, Smart Museum of Art, University of Chicago

Andrea Zittel

The following are part of an installation that also includes a painted wall and carpet

21. *Prototype for Billboard at A-Z West: "These Things I Know For Sure #1,"* 2005
Flashe and polyurethane varnish on birch plywood
41 x 71 in. (104.1 x 180.3 cm)
Hort Family Collection

22. *Raugh Shelving Unit with Fiber Form Bowls and Found Objects from A-Z West*, 2005
Laminated ACX plywood, cardboard boxes with burlap and plaster, fiber form bowls, and found objects
108 x 144 x 37 in.
(274.3 x 365.8 x 93.9 cm)
Hort Family Collection

23. *Single Strand Shapes: Forward Motion (Big Black and White X)*, 2005
Crocheted sheep and llama wool
6 ft. 9 1/2 in. x 6 ft. 9 1/2 in.
(208.3 x 208.3 cm)
Hort Family Collection

Reproduction Credits

Courtesy Allora & Calzadilla, Galerie Chantal Crousel, Paris, and Lisson Gallery, London: 31, 33, 35, 37–38
Sara Black; courtesy WochenKlausur: 135, 139
Julio Castro; courtesy Learning Group: 68–69
Aurelia Collados de Selva; courtesy WochenKlausur: 40–41
Andrei Cypriano; courtesy Liyat Esakov and Marjetica Potrč: 112
Paul Domela; courtesy Marjetica Potrč: 116
Marianne Fairbanks and Jane Palmer, courtesy JAM: 53, 56–57
Courtesy Ronald Feldman Fine Arts, New York: 23
Gianfranco Gorgoni; courtesy James Cohan Gallery, New York; Art © Estate of Robert Smithson / licensed by VAGA, New York, NY: 22
Dejan Habicht; courtesy Marjetica Potrč: 114–115
Courtesy Nils Norman and American Fine Arts Co.: 90
Courtesy Nils Norman and Institute of Visual Culture Cambridge: 87
Rikke Luther; courtesy Learning Group: 61, 63
Myriel Milicevic; courtesy Free Soil: 45
Dieter Schwerdtle; Art ©2005 Artists Rights Society (ARS), New York/VG Bild-Kunst, Bonn: 25
Stephanie Smith; courtesy Smart Museum of Art, University of Chicago: 17
Tom van Eynde; courtesy Smart Museum of Art, University of Chicago: 2–3, 43, 63, 55, 75, 85, 95, 101, 103–105, 107, 109, 121, 125, 129, 131, 137, 148
Tom van Eynde; courtesy Brennan McGaffey: 73, 77
Frances Whitehead: 127, 131, 132

Allora & Calzadilla

Jennifer Allora (American, b. 1974)
Guillermo Calzadilla (Cuban, b. 1971)

Allora & Calzadilla have had solo shows at institutions including the Institute of Contemporary Art, Boston (2004), the Americas Society, New York (2003), and Museo de Arte de Puerto Rico, San Juan (2001). Major group exhibitions include *Only Skin Deep: Changing Visions of the American Self*, International Center of Photography, New York (2003), *Common Wealth*, Tate Modern, London (2003), *How Latitudes Become Forms: Art in a Global Age*, Walker Art Center, Minneapolis (2003), and Bienal de São Paulo (1998).

Jennifer Allora holds an MS from the Massachusetts Institute of Technology and participated in the Whitney Museum of American Art's Independent Study Program. **Guillermo Calzadilla** holds an MFA from Bard College and a BFA from the Escuela de Artes Plasticas, San Juan.

Free Soil

Amy Franceschini (American, b. 1970)
Myriel Milicevic (German, b. 1974)
Nis Rømer (Danish, b. 1972)

Amy Franceschini holds an MFA from Stanford University. She co-founded the group Futurefarmers in 1995 and has had solo exhibitions at the Nelson Gallery at the University of California, Davis (2005) and the Yerba Buena Center for the Arts, San Francisco (1999). Major group exhibitions include the *California Biennial*, Orange County Museum of Art (2004), National Design Triennial, Cooper-Hewitt National Design Museum, New York (2003), *Utopia Now*, California College of Arts and Crafts, San Francisco (2001), Tirana Biennale (2001), and the Transmediale New Media Art Festival, Berlin (2000).

Myriel Milicevic is completing her MA in Interactive Design at the Interactive Design Institute, Ivrea, Italy. She studied graphic design at the Rietveld Academie, Amsterdam, and took courses at San Francisco State University. In 2004 she was the artist in residence at Futurefarmers. She has presented her work in a number of group exhibitions including *Strangely Familiar: Unusual Objects in Everyday Life*, AB+, Turin (2005), and at Filmwinter, Stuttgart (2002).

Nis Rømer holds an MA in architecture and urban planning from the Berlage Institute, Rotterdam, and has also studied at the Rietveld Academie, Amsterdam, and the Jutland Academy of Fine Arts, Denmark. Major group exhibitions and projects include *Staafetten*, Esbjerg Museum of Fine Arts, Denmark (2004), *Smoke on the Water*, a temporary settlement in Tippen, Denmark (2004), and *Stadtflur*, Copenhagen (2002).

www.free-soil.org

JAM

Marianne Fairbanks (American, b. 1975)
Jane Palmer (American, b. 1976)

JAM's most recent work includes *personal power* (2003–ongoing); *sun/light* (2002), during which public newspaper dispensers were rigged to distribute booklets with light-sensitive drawings and photographs; and *transform/transport* (2001), a visual demonstration of the collective capacity for people to generate electricity through daily activity. The artists' work has been seen in several group exhibitions, including *Dragged City*, Rincon, Puerto Rico (2004), *I've got an Answer/I've got an Anthem*, Portland, Oregon (2003), *United Net-Works Mobile Archive Tour*, Sweden (2003), and *Save the Experimental Station*, Chicago (2002). Together Fairbanks

and Palmer cofounded Noon Solar, a portable power design company. They also collaborated with other artists to form Mess Hall, an experimental cultural center in Chicago.

Jane Palmer holds an MFA from the School of the Art Institute of Chicago. She is also a founder of H.A.V.E. (Haitian Visual Arts Education), a nonprofit arts organization in St. Louis de Nord, Haiti. **Marianne Fairbanks** received her MFA from the School of the Art Institute of Chicago. Her work was featured in a solo exhibition at the Fifth Space, Kyoto (1998).

www.jamwork.com

Learning Group

Brett Bloom (American, b. 1971)
Julio Castro (Mexican, b. 1970)
Rikke Luther (Danish, b. 1970)
Cecilia Wendt (Swedish, b. 1965)

Brett Bloom received his MFA from the University of Chicago and is involved with the Chicago-based groups Temporary Services and the Department of Space and Land Reclamation. In addition, Bloom helps to run *Groups and Spaces*, an e-zine that functions as a platform for the collection and distribution of current and historical information on activist art.

Julio Castro is a founding member of Tercerunquinto, a group that has been internationally recognized for architectural interventions that are usually mobilized around the intersection of social and spatial concerns. Recently, Tercerunquinto built *Sculpture at Monterrey's Outskirts* (2002) for a marginalized, impoverished area of Monterrey, Mexico, with the intention of creating a new public space for community use. In 2004 the group was selected to receive a portion of Germany's largest monetary art prize,

the blueOrange. Major group exhibitions include *Dedicated to you, but you weren't listening*, Power Plant Gallery, Toronto (2005), and MUCA ROMA, Mexico City (2004).

Rikke Luther and **Cecilia Wendt** are two of the founders of the Danish collective N55, which blurred boundaries between art and design. Major group exhibitions include *The Interventionists*, Massachusetts Museum of Contemporary Art, North Adams (2003), *Living Inside the Grid*, New Museum of Contemporary Art, New York (2003), and the Venice Biennale (2001).

www.learningsite.info

Brennan McGaffey

(American, b. 1967)

Brennan McGaffey has had solo presentations of his projects at Lampo (2003), TBA Exhibition Space (1999), and RX Gallery (1996), all in Chicago. He has also participated in a number of group exhibitions and collaborations including *Audio Relay* (2002–ongoing), an autonomous, mobile radio station; *Low Altitude Atmospheric and Civic Modifications* (2001), a five-month project hosted by Temporary Services that consisted of mood-enhancing micro-modifications of Chicago's near-atmosphere environment; *Active Music: A New Music Marathon*, Museum of Contemporary Art, Chicago (2000); and *Wall Work*, White Columns, New York (1998). McGaffey is the recipient of the Richard Driehaus Foundation Individual Artist's Grant (2001) and a Finalist Award from the Illinois Arts Council (2000).

www.intermodseries.org

Nils Norman

(British, b. 1966)

Nils Norman is the cofounder of *Parasite*, a collaborative artist-led initiative that has developed an archive for site-specific projects. His work has been featured in solo exhibitions at Galerie für Landschaftskunst, Hamburg (2004), the Institute of Visual Culture, Cambridge, England (2001), and American Fine Arts Co. Ltd., New York (1999). Major group exhibitions include *The Art of the Garden*, Tate Britain, London (2004), Venice Biennale (2003), *Fantastic*, Massachusetts Museum of Contemporary Art, North Adams (2003), Havana Bienale (2003), *Visualizing Geography*, Royal Holloway, London (2002), and *Cities Under the Sky, 4 Free*, BueroFriedrich, Berlin (2001).

Norman received his BA in Fine Art Painting from the Central St. Martins College of Art and Design, London. He has been awarded grants and commissions from organizations and institutions in the United Kingdom, Denmark, and the United States.

People Powered

Kevin Kaempf (American, b. 1971)

Since 2002, under the name People Powered, the Chicago-based artist **Kevin Kaempf** has created programs that address a variety of ecological issues within the city. These include *Soil Starter: Logan Square Composting Network*, a composting program on the Northwest Side; *Loop: Multi-Purpose Coverall*, a piece that focused on the recycling of household paint through reprocessing, mixing, and redistribution; *Collection Continues*, a paint store fully stocked with recycled paint; and *Shared: Chicago Blue Bikes*, a project currently in development to utilize "junked" bicycles that are salvaged, rebuilt, and distributed at subway stations along the Blue Line.

Kaempf received his MFA from the University of Illinois, Urbana-Champaign. Major group exhibitions include *Fine Words Butter No Cabbage*, Hyde Park Art Center, Chicago (2004), *Public Planning*, Experimental Station, Chicago (2002), and *PR'00*, M&M Art Projects, San Juan, Puerto Rico (2002).

www.peoplepowered.org

Dan Peterman

(American, b. 1960)

Dan Peterman is the founder of the Experimental Station, a nonprofit organization based on Chicago's South Side that will open in late 2005 as an incubator for arts, culture, and community initiatives; its rehabbed building implements architecturally and socially sustainable design. Peterman's work has been featured in solo exhibitions at the Museum of Contemporary Art, Chicago (2004), Kunstverein Hannover (2001), Kunsthalle Basel (1998), and Andrea Rosen Gallery, New York (1996); and in group exhibitions including *Skulptur-Biennale Münsterland*, Kreis Steinfurt, Germany (2003), Pyramids of Mars, Barbican Centre, London (2001), the Berlin Biennial (2000), *Dream City*, Museum Villa Stuck, Munich (1999), and *Korrespondenzen/Correspondences*, Berlinische Galerie, Berlin, and Chicago Cultural Center (1994). Peterman holds an MFA from the University of Chicago and teaches at the University of Illinois, Chicago.

Marjetica Potrč

(Slovenian, b. 1953)

Marjetica Potrč's solo exhibitions include MIT List Visual Arts Center, Cambridge, Massachusetts (2005), De Appel Foundation, Amsterdam (2004), Ar/ge Kunst Galerie Museo, Bolzano, Italy (2003), and the Guggenheim Museum, New York (2001). She has also

participated in a wide variety of group exhibitions, notably *Monuments for the USA*, CCA Wattis Institute for Contemporary Arts, San Francisco (2005), *Occupying Space/Wasting Time*, Haus der Kunst, Munich (2005), Liverpool Biennial (2004), Istanbul Biennial (2003), *PARA>SITES: Who Is Moving The Global City*, Badischer Kunstverein, Karlsruhe, Germany (2003), Venice Biennale (2003), and *A New World Trade Center*, Max Protetch Gallery, New York (2002).

Potrč was trained at the Academy of Fine Arts of Ljubljana. She has been awarded a Caracas Case Project Fellowship from the Federal Cultural Foundation, Germany, and the Caracas Urban Think Tank, Venezuela (2002), the Hugo Boss Prize, Guggenheim Museum (2000), a Philip Morris Grant, Berlin (2000), and two Pollock-Krasner Foundation Grants (1993, 1999).

www.potrc.org

Michael Rakowitz

(American, b. 1973)

Michael Rakowitz's solo exhibitions and projects have been held at the Queens Museum of Art, New York (2004) and P.S. 1 Contemporary Art Center, New York (2000). Major group exhibitions include *The Interventionists*, Massachusetts Museum of Contemporary Art, North Adams (2004), *Design Triennial*, Cooper-Hewitt National Design Museum, New York (2002), as well as exhibitions at the Fabric Workshop, Philadelphia, Fri-Art, Fribourg, Switzerland, the Contemporary Art Centre, Vilnius, Lithuania, and the Lower East Side Tenement Museum, New York. He has received UNESCO's Design 21 Grand Prix Award (2002) and the Dena Foundation Art Award (2003).

Rakowitz is Professor of Sculpture at Maryland Institute College of Art, Baltimore. He received his MFA from the Massachusetts Institute of Technology and participated in the Whitney Museum of American Art's Independent Study Program.

www.michaelrakowitz.com

Temporary Services

Brett Bloom (American, b. 1971)
Marc Fischer (American, b. 1970)
Salem Collo-Julin (American, b. 1974)

Major group exhibitions for Temporary Services include *transmediale 05*, Berlin (2005), *Secret Affinities*, La Casa Encendida, Madrid (2004), *Fantastic*, Massachusetts Museum of Contemporary Art, North Adams (2003), *Critical Mass*, Smart Museum of Art, Chicago (2002), and *Autonomous Territories of Chicago*, Hyde Park Art Center, Chicago (2001). With other artists, including JAM, Temporary Services also cofounded Mess Hall, an experimental culture center in Chicago.

www.temporaryservices.org

Frances Whitehead

(American, b. 1953)

Frances Whitehead's most recent solo exhibitions have been at the Oronsko Contemporary Sculpture Center, Poland (2004), and Galerie Menotti, Vienna (2003). Her work has also been featured in many group exhibitions, including *Post-Nature*, Center of Contemporary Art, Ujazdowski Castle, Warsaw (2003–2004), *UnNaturally*, Independent Curators International, New York (traveling exhibition, 2002–2004), *Print Biennial*, Brooklyn Museum of Art, New York (2001), and *History of the Monoprint: 1880 to the Present*, National Gallery of American Art, Washington,

D.C. (1996). Whitehead has also been involved in several public art commissions and installations, including *Watermarks*, an installation presented in conjunction with the Mt. Desert Island Biological Laboratory, Maine (2003), and *Water Table*, a collaborative project for *Settlement: Realizing Civic Discourse*, Spoleto Festival, Charleston, South Carolina (2002–2004). Whitehead is Professor of Sculpture at the School of the Art Institute of Chicago. She received her MFA from Northern Illinois University and has been honored with a NEA individual artist grant, as well as grants from the Ford Foundation and the Illinois Arts Council.

WochenKlausur

Since WochenKlausur's membership has changed over time and the group wishes to emphasize the collective nature of its practice, the current members wish not to be discussed individually here. WochenKlausur describes its projects as social interventions; since 1993 it has worked on labor market policy, community development, substance abuse advocacy, education, homelessness, immigration, and voter rights. One recent, representative project was *Intervention to Improve the Public Perception of Subcultures*, designed in conjunction with the exhibition *The Bourgeois Show: Social Structures in Urban Space*, Dunkers Kulturhaus, Helsingborg, Sweden (2003). In resistance to bourgeois dominance of Helsingborg cultural life, WochenKlausur intervened by establishing an alternative space just outside the museum where diverse, largely marginalized cultural groups were able to give presentations and participate in public discourse.

WochenKlausur's major solo exhibitions and commissioned projects include the Liverpool Biennial (2004), Kulturhuset, Stockholm (2002), *Pfarrplatz*, Kunsthalle and Donau-Universität Krems, Austria (2000), the Venice Biennale (1999), Kunstverein Salzburg (1996), and the Vienna Secession (1992).
www.wochenklausur.at

Andrea Zittel
(American, b. 1965)

Recent solo exhibitions of Andrea Zittel's work have been held at Andrea Rosen Gallery (2005, 2004, 2003), The Contemporary Arts Museum, Houston (2005), Regen Projects, Los Angeles (2004), Philomene Magers Projekte, Munich (2003), IKON Gallery (2001), and Deichtorhallen, Hamburg (1999). Major group exhibitions include *Farsites*, Centro Cultural, Tijuana, Mexico/San Diego Museum of Art (2005), *Female Identities?*, Künstlerinnen der Sammlung Goetz, Neues Museum Weserburg Bremen (2004), the Whitney Biennial (2004), *Passenger: The Viewer as Participant*, Astrup Fearnley Museet for Moderne Kunst, Norway (2002), *Tempo*, Museum of Modern Art, New York (2002), *L'image habitable*, Centre pour l'image contemporaine, Geneva (2002), and *Against Design*, ICA, Philadelphia (2000). Zittel received her MFA from Rhode Island School of Design, and her BFA from San Diego State University. Recent awards include a grant from the Coutts Contemporary Art Foundation as well as the Deutschen Akademischen Austauschdienst (DAAD Grant).
www.zittel.org